ROGER
# FENTON · CAMERON
JULIA MARGARET

EARLY BRITISH PHOTOGRAPHS FROM THE ROYAL COLLECTION

Sophie Gordon

ROYAL COLLECTION PUBLICATIONS

Published by Royal Collection Enterprises Ltd,
St James's Palace, London SW1A 1JR

For a complete catalogue of current publications,
please write to the address above, or visit our website
at www.royalcollection.org.uk

013077

ISBN 978-1-905686-19-3
British Library Cataloguing in Publication Data:
A catalogue record for this book is available
from the British Library.

Designed by Briony Hartley, Goldust Design
Typeset in Caslon
Production by Debbie Wayment
Printed and bound by Conti Tipocolor, Italy
Printed on Gardapart Kiara

## ACKNOWLEDGEMENTS

The permission of HM The Queen to reproduce items
in the Royal Collection and the Royal Archives is
gratefully acknowledged.

The support of a number of colleagues in the Royal Household
is much appreciated.

The assistance of the following people and institutions
is gratefully acknowledged:
Christopher Bunch
Malcolm Daniel, Metropolitan Museum of Art, New York
Philippe Garner, Christie's, London
Deirdre Grant, Aberdeen Art Gallery
Kathy Haslam, Lakeland Arts Trust, Blackwell
Michael Hunter, English Heritage, Osborne House,
    Isle of Wight
Brian Liddy, National Media Museum, Bradford
National Rifle Association, Bisley
Penny Sexton, Royal Albert Memorial Museum
    and Art Gallery, Exeter
Roger Taylor, De Montfort University

## ABBREVIATIONS

| | |
|---|---|
| Journal | Queen Victoria's Journal (RA VIC/MAIN/QVJ) |
| RA | Royal Archives |
| RCIN | Royal Collection Inventory Number |

# CONTENTS

# INTRODUCTION

This selection of photographs by Roger Fenton (1819–69) and Julia Margaret Cameron (1815–79) highlights the existence of some of the finest works in the Royal Photograph Collection, by two leading photographers of the nineteenth century. Both photographers were highly accomplished artists, although they set out to achieve different objectives, with widely differing results. Both photographers also represent the collecting interests of Queen Victoria and Prince Albert – who were dedicated to supporting and acquiring the work of British photographers from 1842 onwards. These examples by Fenton and Cameron show in different ways what appealed in photographic terms to the Queen and Prince Consort and, at the same time, serve as examples of how the royal couple engaged with the growing photographic world as they built up their collection in the 1850s and 1860s.

## A NEW REIGN AND A NEW TECHNOLOGY

When Prince Albert visited the photographic studio of William Constable (1783–1861) in the seaside town of Brighton in March 1842, he took the first steps towards creating the complex and sometimes controversial relationship that exists between the royal family and the camera. Queen Victoria had been on the throne since 20 June 1837, less than five years, and had married Prince Albert on 10 February 1840. The new science of photography, developed simultaneously in France and Britain, had been revealed to the public at the beginning of 1839. The new reign and the new technology were to grow together, the early and enthusiastic patronage of the royal family supporting the technology that came to record their every move. Prince Albert's photographic

session on 7 March, which resulted in at least eight portraits, of which two are known to have been considered satisfactory, was the first time a member of the British royal family had sat successfully before the camera.[1] The Prince had also visited the studio on 5 March but, because of the poor weather and lighting conditions, it had proved impossible to obtain a result.[2]

Queen Victoria mentioned the Prince's first visit to the studio in her journal: 'Albert sat yesterday to a man who makes photographic likenesses' (Journal, 6 March 1842). The following day, in the evening, Constable delivered the portraits from the second session to the Royal Pavilion. The Queen wrote: 'Saw the photographs, which are quite good' (Journal, 7 March 1842).[3]

The brevity of the Queen's entries suggests that there was nothing particularly remarkable about the event; the daguerreotypes, which today remain historically important, are small and not particularly impressive. They certainly could not compete either with the scale and formality of larger oil paintings, nor with the colour and distinction of smaller, more intimate, miniature works. The *daguerreotype process*, named after its inventor Louis Daguerre (1787–1851), creates positive images directly in the camera, without the use of a negative, by exposing a highly polished copper plate coated with a thin layer of silver. The resulting image, which was initially invisible ('latent'), was developed through immersion in mercury vapour. The development process was then halted in a salt solution, thus creating a unique and laterally reversed photographic image. Colour could be added to the image by painting onto the surface of the work, but this highly skilled technique rarely achieved the desired result of a 'true-to-life' image.

Constable had established his Brighton studio, the 'Photographic Institution', on 8 November 1841. Brighton had grown in importance over the previous half-century,

particularly with the presence there of the future King George IV, whose exotic Royal Pavilion was finally completed in 1822. Although Queen Victoria found its lack of privacy vexatious, and was to make her last visit to the Royal Pavilion in February 1845, the presence of the court in Brighton in the early 1840s offered Constable a noble clientele to patronise his business, while at the same time these sitters provided support and respectability to this new and developing technology.

Only members of the royal family and some of their close private circle would have seen the daguerreotypes of Prince Albert. During the 1840s photographs (particularly daguerreotypes) were small, intimate documents, often housed in delicate leather cases destined for a limited circulation. These early royal photographs were never intended to be seen by the public. Even so, the attendance of Prince Albert and others in his entourage at the studio was noted publicly, and in being photographed the Prince was demonstrating his early interest in the technology.

A few years later, in the mid-1840s, the Queen was photographed for the first time seated next to her eldest child, Victoria, the Princess Royal. The portrait, for many years known only through a later carbon print copy, has been attributed to Henry Collen (1800–75), the Queen's miniature painter, who took up photography by acquiring a calotype licence in August 1841 from William Henry Fox Talbot (1800–77). More recently, however, it has been possible to identify the original photograph of Queen Victoria as a daguerreotype by an as yet unidentified photographer. The original daguerreotype was copied for the Queen in the 1870s; the medium is clearly visible in the resulting negative and the mark of the French silversmith firm Christofle appears on the edge of the plate. Silver plating was regulated and controlled by law; the appearance of the manufacturer's mark confirms that the object is a daguerreotype.

The *calotype process* resulted in a negative image on paper (known as a calotype), which was developed and fixed, and could then be used to print almost any number of positive images. An early commission demonstrated the benefit of this. In December 1842 Henry Collen was employed by the Foreign Office to make a number of photographic facsimiles of the Treaty of Nanking. The treaty marked the end of the First Opium War (1839–42) and it ceded Hong Kong to Britain. A section was written using Chinese characters and none of the scribes at the Foreign Office could be relied upon to copy the text accurately. Collen was called in to photograph this section of the treaty, and a copy was sent to Queen Victoria. The Foreign Secretary, Lord Aberdeen, wrote a letter to accompany the bound document, and both the letter and photographs survive in the Royal Library today. Writing extremely presciently, Aberdeen stated that, in his opinion, photography 'may lead to consequences of which at present we have very little conception'.[4]

Initially, the daguerreotype process was more successful than Talbot's calotype process because of its ability to create sharper, more life-like images, but the calotype process continued to be used as well, particularly for topographical and architectural photography, as well as for recording works of art. The calotype, unlike the daguerreotype, was a relatively easy process to manipulate, and could be learnt by amateurs. In 1851, however, Frederick Scott Archer (1813–57) discovered a way to use collodion on glass as a binding medium for the light-sensitive chemicals needed to create a negative (see p. 64). Although this was a much more complicated process to employ, the resulting images were infinitely superior, with two major advantages: the glass plate negative meant that the positive prints were sharp; and the chemicals used were more sensitive to light than in a calotype, leading to far shorter exposure times – two or three seconds, depending on the light conditions. With the introduction of an image as sharp as the daguerreotype but costing a fraction of the price, more photographers turned to the wet collodion process.

## THE GROWTH OF THE ROYAL PHOTOGRAPH COLLECTION

Both the Queen and Prince Albert continued their early interest in photography, commissioning and acquiring

Unknown photographer,
*Daguerreotype of Queen Victoria
and the Princess Royal, mid-1840s;*
glass plate negative, late 1870s
(RCIN 2506821) 15.2 x 12.7 cm

new works, often portraits of themselves and their growing family, during the late 1840s and 1850s. Daguerreotypes by leading practitioners, including William Kilburn, Antoine Claudet and Richard Beard, survive in the collection today, as do many albums and photographically illustrated books, such as a copy of *Sun Pictures in Scotland* (1845) by Talbot, reflecting the various interests of the royal couple.

In broad terms, Prince Albert's photograph collection encompasses architecture, topography and genre scenes, while that of the Queen concentrates on portraiture and human interest. Within the Prince's collection, albums cover subjects such as the scenery of England, Wales, Scotland and particularly the Balmoral estate, but the key to his collection lies within the four albums entitled 'Calotypes', which contain around 400 photographs that date between 1850 and 1861. These albums include work by the leading British photographers of the day, amateur and professional, covering a range of subject matter. Some of the work would have been available on the commercial market, but much was commissioned privately for the royal family. While the earliest surviving album contains a large number of photographs of works of art and paintings, as the years passed the number of photographs 'from life' in the albums increased, including works by Francis Bedford, Roger Fenton, Nicolaas Henneman, Oscar Rejlander and Robert Macpherson.

Also represented in the 'Calotypes' albums is the work of Prince Albert's librarian Dr Ernst Becker (1826–88). Becker entered the Royal Household in May 1851, and more than any other individual was the person responsible for establishing and sustaining a connection between Prince Albert and the professional world of photography. Becker, an accomplished photographer in his own right, was a founding member of the Photographic Society (established in 1853) and taught photography to the Prince of Wales and Prince Alfred. Becker advised Prince Albert on potential purchases and often acted on his behalf in obtaining prints, as well as photographic equipment. He was also sometimes responsible for making payments to photographers. A receipt from Roger Fenton dated 26 August 1855 acknowledges

a payment of £17 9s 6d from Becker for photographs of the Indian Princess Victoria Gouramma of Coorg, delivered at the beginning of the year.[5]

The Prince, aided by Becker, also embraced the possibilities offered by photography as a medium for copying works of art. He believed that art could serve a moral and educational purpose and that photography could aid the dissemination of information to a wider audience. Objects in the Royal Collection were photographed when loaned to exhibitions, or simply for record-keeping. The Prince's most ambitious photographic project, referred to as the 'Raphael Collection', was an attempt to compile a visual record of all works of art by Raphael from both public and private collections. Having completed a photographic record of Raphael's works in the Royal Collection, Prince Albert turned to obtaining copies from collections across Europe. The project employed many leading photographers of the day, including Robert Howlett, Joseph Cundall, Roger Fenton and Charles Thurston Thompson. The scale of the project meant that its completion proved more complicated than at first anticipated. Although the task began in 1853, it remained unfinished at the time of the Prince's death in 1861. Queen Victoria wished that the undertaking be continued, however, and it was eventually completed in 1876. Only one full set of 49 portfolios was ever produced and is today housed in the Print Room at Windsor Castle.

During the Prince's lifetime, many photographic acquisitions were made jointly, and sometimes it is hard to determine who was responsible for selecting the works that arrived in the Royal Collection. The Queen wrote about the evenings she and Prince Albert would spend together, pasting watercolours, prints and photographs into albums, recalling places where they had travelled. In 1862 she reminisced: 'but the principal ones … were the small Albums of the Photographic "Cartes de Visite" wh. for the last 2 years has been a great amusement; he delighted in them & went on buying constantly fresh ones – & always placed them himself – how he wished they shd. be fixed. There are 14 Vols: <u>all</u> differently classed – according to Rank – Nation &c.'[6]

The Queen was herself an enthusiastic collector of *cartes de visite*. These small albumen print portraits, roughly the size of a business card, became a collecting craze amongst the upper and middle classes in the late 1850s and 1860s. The format had been patented in November 1854 and it allowed the production of a relatively cheap personal portrait that could be easily distributed to friends and family. Within a few years, thousands of *cartes* were being commissioned annually, exchanged and pasted into specially designed albums. In November 1860 the Hon. Eleanor Stanley, one of the Queen's ladies-in-waiting, was to write about the Queen's attempt to collect portraits: 'I have been writing to all the fine ladies in London, for their or their husband's photographs, for the Queen; ... I believe Miss Skerrett is right when she says "she [the Queen] could be bought, and sold for a Photograph!"'[7]

At the same time, a market for portraits of well-known figures and celebrities developed. The Queen, who had not previously allowed photographers to publish their images of her and the royal family, took the decision to allow John Jabez Edwin Mayall (1813–1901) to release royal portraits taken during a session on 15 May 1860 (plates 1 and 2). Mayall issued his portraits as *cartes de visite* which subsequently sold in their thousands. The royal family themselves thus became a valuable commodity within the public domain.

The albums of portraits and *cartes de visite* that survive in the Royal Collection today indicate that the Queen continued to acquire this type of material after the death of the Prince Consort. The Prince's 'Calotypes' albums end abruptly at his death in December 1861, but the portrait albums continue, in some cases into the 1890s. The most extensive series of albums is entitled 'Portraits of Royal Children'. It consists of 44 albums, beginning with the Queen's children in the late 1840s and ending in 1899 with portraits of some of the Queen's great-grand-children, including the future King George VI. Many of the leading British and European photographers of the nineteenth century are represented, such as W. & D. Downey, Hills and Saunders, Leonida Caldesi, Robert Milne and, most notably, Roger Fenton.

## ROGER FENTON (1819–69)

Roger Fenton was born on 28 March 1819, at Crimble Hall near Bury, Lancashire. His grandfather was a merchant and banker; his father was a businessman and, from 1832, the Member of Parliament for Rochdale. He was educated at University College, London and went on to train to become a barrister, although he was not called to the bar until 9 May 1851. Fenton had married in 1843 and during the 1840s he and his wife Grace travelled to Paris so he could develop his interest in the fine arts by undergoing training there. To this end, Fenton registered as a copyist at the Louvre in June 1844. He returned to London a few years later and it is believed that he studied in 1847 with the painter Charles Lucy (1814–73), who was known in particular for his historical paintings. Lucy remained a part of Fenton's circle and some years later he was to appear in his photographs. Fenton also began a friendship with Ford Maddox Brown (1821–93), an artist who had a close association with the Pre-Raphaelite Brotherhood and who shared a studio with Lucy at this time. Maddox Brown mentions Fenton in his diary on several occasions, in particular recording the occasion when, following the death of Fenton's eldest

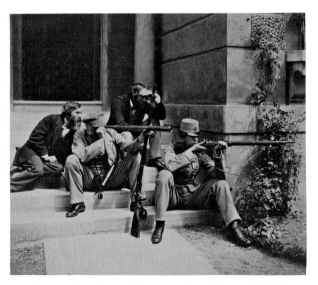

Roger Fenton, *Charles Lucy with Horatio and Edward Ross, and J.M. Parker, 1860*; albumen print (RCIN 2935169) 23.7 x 27.9 cm

daughter on 12 March 1850, he painted a portrait of the dead child.[8]

Fenton's earliest surviving photographs date from 1852, although already during the previous year he was in touch with photographers in France – including Gustave Le Gray – as well as visiting the Société Héliographique (the French photographic society, established in 1851). On his return, Fenton published an article arguing the case for a similar society to be set up in London. During 1852, Fenton continued his efforts to establish a photographic society, and eventually, on 20 January 1853, the inaugural meeting of the group was held at the Society of Arts, with Fenton as one of the Council members.

Fenton had travelled to Russia in August 1852 to photograph an engineering project to construct a bridge across the River Dnieper. He took the opportunity to take photographs in Moscow and Kiev as well, and a few of these images were exhibited in December 1852 (alongside many more of Fenton's images taken in Britain) at the first British exhibition devoted exclusively to photography, held at the Society of Arts.

That exhibition, a landmark in the history of photography, was followed a year later by the first annual exhibition of the Photographic Society, in December 1853. The exhibition proved to be a key moment in Fenton's career as he was asked to escort Queen Victoria and Prince Albert around the exhibition when they visited on 3 January 1854. The appearance of the royal couple at the exhibition was commented on in the press the following day and the photographs that appealed to the Queen were discussed. Of particular interest was the group of animal studies taken in 1852 at London Zoo by the Comte de Montizon. The Queen subsequently acquired a set of 43 of the Comte's photographs. The very public support given by the Queen and Prince Albert to this still complicated new technology was important while photography struggled to raise its profile.

It is possible that Prince Albert had encountered Fenton previously, which might partly explain the patronage he was to receive from the royal couple. In 1850 Prince Albert was a driving force behind the establishment of the North London School of Drawing and Modelling.[9] A number of prominent artists, including Fenton and his friend Charles Lucy, were involved in the administration of the school. It tried to use the arts in various forms to improve working men's lives, both in a practical way, by providing them with new skills, and through a more philosophical route, by exposing them to the fine arts. This demonstrated the Prince's belief in the power of art to improve the morals of those who encountered it.

Shortly after Fenton had shown the Queen around the exhibition, he was invited to Windsor Castle to photograph the six eldest royal children. On 16 January 1854, the children had dressed up as characters from *Les deux petits savoyards* (1789), a popular comic opera in which the leading characters were two young boys, played by Princess Alice and Prince Alfred. Exactly a week later, on 23 January, they appeared in their costumes before Fenton to be photographed.[10] Just two days later, Fenton returned to photograph the Queen with the children. The results from these sessions were evidently deemed to be successful, as Fenton was to return to the Castle and to Buckingham Palace several times throughout 1854, producing a series of often striking portraits of the Queen, Prince Albert and their children.

One of Fenton's most significant royal commissions during 1854 was to photograph another theatrical production. To mark their parents' fourteenth wedding anniversary, the royal children (seven of them at this time) prepared various static tableaux depicting the four seasons. They performed this in front of an audience on 10 February 1854. The children dressed up in costume, presenting each season in turn, and concluding with a tableau involving everyone. The tableaux were re-enacted for the camera and the photographs were used as the basis for watercolours by Carl Haag. The completed portfolio was presented to the Queen by Prince Albert on her thirty-fifth birthday on 24 May 1854. The portraits of the royal children in a variety of poses are sometimes elegant, occasionally recalling compositions borrowed from Greek sculpture. They are also sometimes clumsy and almost comical, as the very young children reluctantly try to hold their poses long enough. The photographs,

made as intermediate images for a private commission, were only ever intended for the smallest of audiences.

Fenton also visited Buckingham Palace on several occasions in 1854 to make portraits of the Queen and Prince Albert. They are shown presenting a variety of characters and poses, perhaps testing the possibilities of the camera as they explore the different identities that they themselves had to adopt. The Queen is shown in a series of domestic poses, standing next to Prince Albert as he reads; on another occasion, the Prince is shown standing alone, facing the camera directly in a dramatic and forceful pose. The Queen and Prince Albert are shown together as successful parents with their eight children in the grounds of the Palace (their ninth and youngest child, Princess Beatrice, was born on 14 April 1857). In addition, the Queen and Prince are shown in Court dress, appearing as sovereign and consort for the first time in a photograph.[11] None of these images, however, was intended to be seen beyond the private circle of the royal couple and as a consequence, few examples of this aspect of Fenton's work have survived outside of the Royal Collection. Fenton's unprecedented access to the private life of the royal family undoubtedly had a great impact on his career, while Fenton himself had a profound effect on Queen Victoria and Prince Albert, sustaining and developing their burgeoning interest in photography.

In addition to the commissioned work, Prince Albert acquired examples of Fenton's commercial photography. Early architectural studies and topographical views appear in the 'Calotypes' albums, revealing the Prince's interest in architectural photography. Also in the fourth volume of the 'Calotypes' albums is the narrative sequence of four images from 1854 known as *A Romance*.[12] These photographs depict, in a slightly humorous fashion, the meeting of a young couple *A Strong Flirtation*, their engagement *Popping the Question* and the subsequent two scenes, *Sealing the Covenant* and *The Honeymoon*. While other photographers such as Oscar Rejlander and, later, Julia Margaret Cameron are known for producing work that contains strong narrative themes, this sequence is unique within Fenton's oeuvre. Throughout his career,

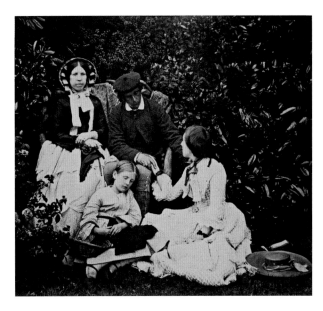

Roger Fenton, *A Romance No. 1. Strong flirtation of which one Spectator highly disapproves, 1854*; albumen print from the album 'Calotypes vol. IV' (RCIN 2906163) 18 x 21.3 cm

however, Fenton did experiment with a variety of genres within his photographic output. His strong connection with the contemporary art world, as well as with other photographers through the Photographic Society, would have made him aware of the range of work being produced during the 1840s and 1850s. It is possible that the outdoor setting and the subject matter of *A Romance* are influenced by the ideas of the Pre-Raphaelite Brotherhood. The less-than-serious presentation of the theme, however, is entirely Fenton's own.

## THE CRIMEAN WAR 1854–5

During 1854 Fenton photographed the Fleet Review, which took place on 10 and 11 March, off the south coast of England at Spithead. The review, which traditionally took place in the presence of the monarch, was organised for particular occasions, such as the departure of the fleet during wartime, or to mark a jubilee. This particular event was held in the face of possible war between Britain and Russia. There was a fear that Russia would attack Britain's

fleet in the Baltic Sea, so in response the Royal Navy amassed a fleet under the command of Sir Charles Napier. The Queen, on board HMS *Fairy*, reviewed the fleet, sailing through a path created by the ships. On the following day HMS *Fairy* led the fleet out of Spithead on its way to the Baltic. Seventeen days later, on 28 March, Britain declared war on Russia, the consequences of which would take Fenton to the Crimea in 1855 on a dangerous photographic expedition.

There is no evidence that Fenton's work in the Crimea was a direct commission from the royal family but, by Fenton's own account, he did travel with letters of introduction written by Prince Albert, which would have allowed him swifter access to the higher commanders within the army. In February 1855, Fenton set out from Britain for southern Russia, where the war was taking place; Britain was allied with France and Turkey against Russia. Fenton's expedition was underwritten by the publisher Thomas Agnew & Sons, who undoubtedly anticipated healthy sales of his work due to the public interest in the conflict. Fenton took about 700 glass plates with him, and returned with approximately 350 viable images in the summer of 1855. Prints were shortly afterwards seen by the Queen and Prince Albert at Osborne House; the Queen wrote that she saw 'portraits & views, extremely well done – one, most interesting of poor Lord Raglan, Pélissier & Omar Pasha, sitting together, on the morning, on which the Quarries were taken' (Journal, 8 August 1855).[13] A set of 350 photographs was eventually acquired for the Royal Collection, but it is not clear whether it was Prince Albert or his eldest son, the Prince of Wales, who made the acquisition. There is no surviving invoice and the photographs could have been a gift from Fenton. It has traditionally been thought that the Prince of Wales acquired the Crimean photographs, along with a smaller album of 31 portraits of officers in the Crimea, as in the later nineteenth century the material was located in the library at Sandringham, the house purchased for the Prince of Wales in 1862.[14]

## AFTER THE CRIMEAN WAR 1855–62

Following his return from the Crimea, Fenton undertook one further commission for the royal family. He made a series of photographs at Balmoral in September 1856 (plates 3 to 5). The Balmoral visit was the last direct contact Fenton had with the Queen or Prince Albert, although they continued to acquire, through gift and purchase, examples of his work for their expanding collection. These included a set of the photographs that Fenton took in July 1860 at the meeting of the Rifle Association held on Wimbledon Common (plates 12 to 14). Queen Victoria attended the meeting, firing the first shot from a specially prepared rifle as well as conducting a review of the Volunteer Rifle Corps, who had turned out for the event. Following the meeting, the association voted that a set of the photographs should be presented to Prince Albert, who had become the first patron of the Association. Also recorded in the Association archives is a vote of thanks addressed to 'Mr Fenton for having presented the copyright of his photographs of the Wimbledon meeting, to the association, and also informing him of his having been made a life member of the association.'[15]

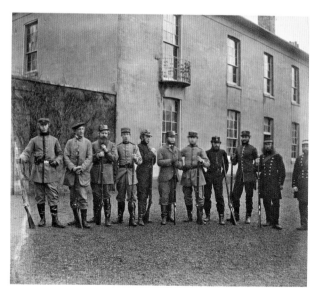

Roger Fenton, *Volunteer class at Hythe, Feb. 1860. The first section;* albumen print (RCIN 2942135) 25.2 x 28.7 cm  Fenton is the third from the left

The Volunteers had been raised in 1859 in response to the weakening strength of Britain's military force following the Crimean War, and the growing possibility that another European conflict was imminent while the Franco–Austrian War raged in northern Italy. Fenton joined the 9th (West Middlesex) Volunteers in 1860 and in February attended the Hythe School of Musketry for rifle training.[16] He appears alongside his comrades in one of the photographs he took at Hythe in 1860.[17] Also photographed was Horatio Ross (1801–86), one of the most prominent and accomplished sportsmen of the Victorian age (plate 16). Ross was a pioneering photographer, actively involved in the Photographic Society of Scotland, serving as both Vice-President (1856) and President (1858). Shortly after the meeting of the Rifle Association, Fenton made some portraits of his friend with Ross's son Edward, who had won the Queen's Prize for his shooting prowess. The painter Charles Lucy also appeared in one of the images (see p. 7).

In the late 1850s, a growing number of commercial photographers were invited to photograph the Queen and her family, in particular J.J.E. Mayall, Camille Silvy and Frances Day. The relationship that was established with Fenton in 1854 seems not to have been repeated with any other photographer, however, possibly because with the growth and commercialisation of photography, the type of individual working as a photographer was changing, as was the nature of photography. The intimate, domestic quality of the process was being eroded into something far more public and uncontrollable. It was perhaps a gradual awareness of this that began to change the relationship the royal family had with photography.

The last substantial acquisition made from Fenton was the set of views of Windsor taken in 1860 (plates 6 to 11). It was not a commission from the Queen, but the largest known set of these images to have survived is that in the Royal Collection. Fenton's invoice states that both a large set and a small set were supplied in July 1860, followed by four large unmounted views and three small unmounted views at the beginning of August.[18] The set that has survived in the Royal Collection contains thirty-five mounted photographs, of two different sizes.[19]

The views concentrate on the immediate surroundings of the Castle. Some show areas that were publicly accessible, but others are picturesque scenes from the private areas of the Home Park, and Fenton would have required permission in order to work in these restricted areas. This suggests that although he was not working for the royal family, the relationship between Fenton and the Queen was still a good one. Fenton exhibited some of the Windsor views at the Photographic Society exhibition in 1861, but it was around this time that he began to withdraw from the photographic world.

Shortly after, Fenton retired completely from photography. He sold his photographic equipment and remaining negatives at auction and returned to his first profession, the law. More than anyone else, Fenton was responsible for making photography a respectable, publicly acceptable visual art through societies, exhibitions and journals. Fenton's photographs were often printed in portfolios with lithographed captions and plate marks, so that they appeared almost identical to the volumes of engravings and lithographs that the public was already used to purchasing. By 1862, when he gave up his camera, photography had evolved into a far more cut-throat commercial practice. This changed the way that consumers related to photographers and their art form, and may have been one of the reasons that Fenton gave up photography. But for the royal family it was perhaps the death of Prince Albert, on 14 December 1861, that altered the nature of their relationship with the photographic world.

## THE DEATH OF PRINCE ALBERT

Prince Albert was diagnosed with typhoid fever on 9 December 1861 and died five days later at Windsor Castle. Queen Victoria was devastated by his death. As part of the many rituals maintained to preserve his memory, the Queen ensured that the Prince's rooms were kept as they had been during his life. Two days after his death, the Windsor-based photographer William Bambridge (1820–79) was summoned to the Castle to take what are perhaps the most poignant photographs in

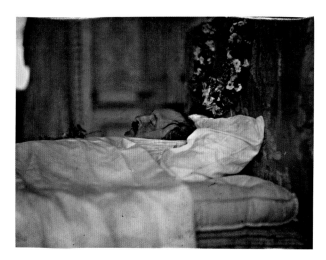

William Bambridge, *Prince Albert after death, the Blue Room, Windsor Castle, 16 December 1861*; carbon print, late 1870s (RCIN 2506826) 13.2 x 17.6 cm

the entire collection.[20] Two photographs have survived that show Prince Albert upon his death bed. The Queen had the negatives for these prints destroyed, presumably in order to prevent further copies being produced.[21]

The death of the Prince was to have an impact on the collecting activities of the Queen. Her own interests eventually reasserted themselves, and she focused particularly on her growing collection of photographic portraits. The material she acquired continued to concentrate on her children and extended family, but portraits of accomplished individuals, actors, musicians, politicians and celebrities of the day also found a place in the Queen's albums. One of the most significant acquisitions that the Queen made was a number of portraits by Julia Margaret Cameron.

## JULIA MARGARET CAMERON (1815–79)

Julia Margaret Pattle was born in India into an artistic, professional family. She met her future husband, Charles Hay Cameron, in 1836 in Cape Town, South Africa, where she was recuperating from an illness. He was a prominent member of the British administration in India, working for the Council of Education, and was

eventually to become a member of the Supreme Council of India. After they married in 1838, the Camerons spent some time in Calcutta before Charles retired in 1848 and they moved to England.

The Camerons lived initially in London, where Julia came into contact with many of the leading writers and painters of the day through her sister, Sarah Prinsep, who held a popular salon for artists. Visitors included Alfred Lord Tennyson, the Poet Laureate, and George Frederic Watts, the painter. In 1860 Cameron went to the Isle of Wight to visit Tennyson, who had moved to the village of Freshwater to escape from public attention. Cameron was greatly struck by the village and its surroundings and soon purchased a property close to the Tennysons', which she named Dimbola Lodge. The royal family had owned Osborne House on the northern coast of the Isle of Wight since 1845 but, despite the relative proximity of them to Freshwater, there does not seem to have been any personal contact between the Camerons and the Queen. Cameron did state in her autobiographical note that she had photographed the Princess Royal and her husband Prince Frederick William of Prussia, although no photographs from that sitting appear to have survived.

Cameron was given a camera by her daughter in 1863, and she took what she described as her first successful photograph in January 1864.[22] She quickly grasped the practicalities of the medium and in the following year held an exhibition of her work in London. Cameron produced portraits, the composition of which was influenced strongly by the Pre-Raphaelite painters. She used friends, family and neighbours as models, often basing her works on literary, classical or religious themes. Two early examples, both purchased by Queen Victoria in 1865, exemplify this.[23]

The first is titled *Paul and Virginia* (1864), after the eponymous novel of 1788 by Jacques-Henri Bernardin de Saint-Pierre. The book was enormously successful, telling the romantic story of two children, Paul and Virginia, who grow up on an isolated island paradise, free from the corrupting influence of the modern world. The theme appealed to Queen Victoria; in 1851 Prince Albert gave the Queen a marble sculpture of Paul and Virginia by

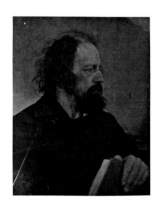

Julia Margaret Cameron, *Alfred, Lord Tennyson*, May 1865; albumen print (RCIN 2941863) 25.2 x 20 cm

Guillaume Geefs, purchased at the Great Exhibition.[24] Four versions of the photograph were produced by Cameron.

The second photograph acquired was *Whisper of the Muse* (1865), today one of Cameron's best-known portraits. It portrays the painter George Frederic Watts as a musician holding a violin, seated between two children who – as muses – whisper inspiration to him. The subject matter owes its concept to the classical world.

Although neither of these works remains in the Royal Collection, it is notable that the Queen purchased these photographs at an early point in Cameron's career, most probably prompted by the exhibition of Cameron's photographs at the printsellers P. & D. Colnaghi in July 1865.[25] Apart from the two images discussed above, the Queen also acquired portraits of Tennyson and Henry Taylor for their literary associations. Tennyson had been the Poet Laureate since 1850, and Taylor, although largely forgotten today, was at the time a well-known writer and dramatist. It is perhaps the manner in which Cameron approached her sitters, however, that would have appealed particularly to the Queen. Cameron presented her male sitters as objects for admiration and worship. She did this by framing the head of her sitter with dark clothing and a dark background, almost creating an aura around the subject of the work. Some of her portraits were also slightly out of focus, deliberately so, which gives the image a sense of movement and dynamism. The portrait of the writer Thomas Carlyle (plate 19) seems to show a man whose greatness cannot be contained within the frame of the image. Cameron sought sitters whom she believed were heroic through their achievements. She was to write to Henry Taylor that men were great through their genius, while women achieved greatness through love.[26] Queen Victoria, who was passionate and admired genius when she encountered it, would have found this an appropriate approach. It is interesting that when the Queen made subsequent purchases of Cameron's work, she acquired only the portraits of 'great men' rather than any of Cameron's allegorical work.[27] Some years later a copy of a book containing portraits by Julia Margaret and her son Henry Herschel Hay Cameron, *Alfred, Lord Tennyson and his Friends* (London, 1893), was added to the Royal Library.[28]

Queen Victoria's purchase of the Cameron photographs marks the return of royal patronage to original and groundbreaking photography following the death of Prince Albert. Cameron's portraits are unlike anything that commercial, studio-based photographers were producing at that time and she remains one of the most original photographers to have worked in the nineteenth century.

Throughout the rest of her life, Queen Victoria continued to be photographed and to acquire photographic material for the collection. Some of the items received were gifts, following State Visits and diplomatic events. Other occasions, such as jubilees, national events, family weddings and christenings, prompted the exchange of prints. The collection, built on the early interest and joint patronage of Victoria and Albert, gradually grew into a remarkable repository of images, reflecting both the public and private lives of the collectors involved. The size of the collection at the time of Queen Victoria's death in 1901 has been estimated at 20,000 images. Today it is possible to distinguish the different approaches taken by the Queen and the Prince, but the collection grew to the extent it did because ultimately they shared the same passion for exploring art.

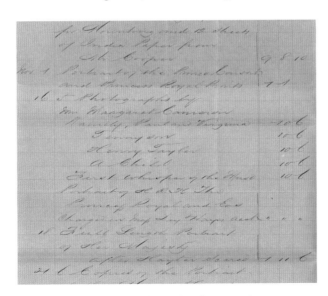

Invoice for Cameron's photographs purchased 'Xmas 1865' (RA PPTO/PP/QV/PP2/101/10370)

## NOTES

1 One of the daguerreotypes is known today only through a late nineteenth-century copy, created by the firm of Hughes & Mullins when Queen Victoria feared her photograph collection might fade away: RCIN 2932488 (surviving daguerreotype); RCINS 2931356.d-e (later carbon print copies of the two original daguerreotypes) from the album 'The Queen's Private Negatives Volume 1'.

2 Grece, Journal, 5 and 7 March 1842.

3 Journal, 6 and 7 March 1842.

4 Letter from Lord Aberdeen to Queen Victoria, dated 22 February 1843, inserted into Queen Victoria's copy of the Treaty of Nanking; RCIN 1047556.

5 RA PPTO/PP/QV/PP2/12/5728.

6 RA VIC/MAIN/Z/491/22 January 1862.

7 Stanley 1916, p. 377. Miss Skerrett was the Queen's Dresser.

8 Biographical information for Fenton is taken from *All the Mighty World: The Photographs of Roger Fenton, 1852–1860*, New York, 2004.

9 The North London School of Drawing and Modelling was founded in 1850 by the painter Thomas Seddon (1821–56). It did not last beyond Seddon's death.

10 The casting was the Prince of Wales as le Bailli; Princess Helena as Clermont; Princess Louise as Louison; Princess Alice as José; Prince Alfred as Michael and the Princess Royal as La Marquise.

11 Fenton photographed the royal family on at least nine occasions in 1854. He also took photographs for the Raphael project on 9 August, and at the Queen's request made portraits of Princess Victoria Gouramma of Coorg on 25 November and 1 December 1854. (See note 5 for RA reference.)

12 RCINS 2906163-6 in album 'Calotypes vol. IV'.

13 Journal, 8 August 1855.

14 The main collection of Fenton's Crimean photographs in the Royal Collection consists of 350 individual prints (RCINS 2500229–2500483). The album of portraits contains 31 prints (album RCIN 1039814 containing RCINS 250656–2506595).

15 National Rifle Association archives, Council Book 1, p. 56. There is also an invoice in the Royal Archives from Roger Fenton which includes the supply of 13 Wimbledon views (RA PPTO/PP/QV/PP2/45/1021).

16 Members of the Volunteer movement attended the Hythe School in 1859 and from this gathering emerged the idea for the formation of the National Rifle Association in 1859.

17 The group consists of 17 photographs taken at Hythe in 1860 (RCINS 2942127–2942143). Fenton appears in a group titled 'The first section' (RCIN 2942135; see p. 10) and Ross appears in a group titled 'The third section' (RCIN 2942134).

18 RA PPTO/PP/QV/PP2/45/1021.

19 There are 35 photographs in the set; of these, four are duplicate views.

20 RA PPTO/PP/QV/PP2/57/2998.

21 A large collection of glass plate negatives has survived to the present day. Some negatives are copy negatives; others are the photographer's original plates. Most of the copy negatives were made by William Bambridge and, later, the firm Hughes & Mullins. (See Gent and Gray 1998.)

22 Whilst in India, Cameron had corresponded with the scientist Sir John Herschel (1792–1871) on developments in photography. In 1863, she was visited at her home on the Isle of Wight by the photographer Oscar Rejlander, a friend of Tennyson's.

23 An invoice dated 'Xmas 1865' lists five photographs by 'Mrs. Margaret Cameron': *Paul and Virginia, Alfred Tennyson, Henry Taylor, A Child* and *First Whisper of the Muse* (RA PPTO/PP/QV/PP2/101/10370; see p. 13). The price of each print was 10s 6d. Of this group, only the portrait of Tennyson remains in the Royal Collection today (RCIN 2941863; see p. 13). This, and a second Cameron invoice in the Royal Archives (see note 27), were issued by the printseller John Mitchell, who supplied a wide variety of material to the Queen. All the Cameron portraits in the Royal Collection, however, have an oval blindstamp on the mount, below the photograph, from the London printsellers Colnaghi: *Registered photograph / Sold by Messrs Colnaghi / Pall Mall East / London*. Mitchell was most probably purchasing from Colnaghi and then submitting the items to the Queen.

24 RCIN 41033. Marsden 2010, no. 90.

25 P. & D. Colnaghi, who had been closely connected with royal collecting since the 1790s, established themselves in the photographic world through the printing and distribution of Fenton's Crimean photographs. Cameron rented their space for her exhibition, before establishing an agreement with them to be her principal publishers.

26 Daniel 1999, p. 36.

27 An invoice dated 'Xmas 1867' lists '7 large photographs by Mrs Cameron Various' (RA PPTO/PP/QV/PP2/119/13678). Some of the portraits in the Royal Collection date to 1868 but no 1868 Cameron invoice appears to have survived.

28 The volume (RCIN 1196573) contains King George V's bookplate.

## BIBLIOGRAPHY

Allison, R. and Riddell, S. 1991. *The Royal Encyclopedia*, London

Archer, F. S. 'On the use of collodion in photography', *The Chemist*, new series, 2 (March 1851), pp. 257–8

Baldwin, G., Daniel, M. and Greenhough, S. 2004. *All the Mighty World: The Photographs of Roger Fenton, 1852–1860* (exh. cat.), The Metropolitan Museum of Art, New York; National Gallery of Art, Washington DC; The J. Paul Getty Museum, Los Angeles

Bryant, B. 2004. *G.F. Watts Portraits: Fame and Beauty in Victorian Society* (exh. cat.), National Portrait Gallery, London

Cox, J. (ed.) 1996. *In Focus: Julia Margaret Cameron. Photographs from the J. Paul Getty Museum*, Los Angeles

Cox, J. and Ford, C. 2003. *Julia Margaret Cameron: The Complete Photographs*, Los Angeles and Bradford

Daniel, M. 1999. 'Men Great thro' Genius … Women thro' Love. Portraits by Julia Margaret Cameron', in 'Inventing a New Art: Early Photographs from the Rubel Collection in the Metropolitan Museum of Art', *The Metropolitan Museum of Art Bulletin*, 56 (4), pp. 32–9, New York

Dibble, J. 1992. *C. Hubert H. Parry: His Life and Music*, Oxford

Dimond, F. and Taylor, R. 1987. *Crown and Camera: The Royal Family and Photography 1842–1910* (exh. cat.), The Queen's Gallery, London

Dimond, F. 2009. 'Prince Albert, the Society of Arts and the Beginning of the Royal Photograph Collection', *The William Shipley Group for RSA History Occasional Paper 11*, London

Ford, C. 2003. *Julia Margaret Cameron: 19th Century Photographer of Genius* (exh. cat.), National Portrait Gallery, London

Garner, P. 2003. *A Seaside Album: Photographs and Memory*, Brighton & Hove

Gent, M. and Gray, H. 1998. 'The Rehousing of Queen Victoria's Private Negatives' in *Care of Photographic, Moving Image and Sound Collections: Conference Papers*, 20–24 July 1998, pp. 129–35, York

Grece, Journal. The Journal of Susanna Grece, MS in Smithsonian Institute, Washington DC

Lloyd, V. 1988. *Roger Fenton: Photographer of the 1850s* (exh. cat.), Hayward Gallery, London

Marsden, J. (ed.) 2010. *Victoria and Albert: Art and Love* (exh. cat.), The Queen's Gallery, London

Nash, J. 1848. *Views of the Interior and Exterior of Windsor Castle*, London

Pyne, J.B. 1839. *Windsor, with its Surrounding Scenery, the Parks, the Thames, Eton College &c*, London

Ritchie, A.T. and Cameron, H.H.H. 1893. *Alfred, Lord Tennyson and his Friends: A Series of 25 Portraits and Frontispiece in Photogravure from the Negatives of Mrs. Julia Margaret Cameron and H.H.H. Cameron*, London

Roberts, J. 1997. *Royal Landscape: The Gardens and Parks of Windsor*, New Haven and London

Schaaf, L.J. and Taylor, R. 2005. *Roger Fenton: A Family Collection: Sun Pictures Catalogue Fourteen*, New York

Stanley, E. 1916. *Twenty Years at Court*, ed. Erskine, B., London

Taylor, W.F. c.1856. *W.F. Taylor's Guide to Windsor, Eton and Virginia Water*, Windsor

Taylor, W.F. 1862. *W.F. Taylor's Guide to Windsor, Eton and Virginia Water*, Windsor

Willmore 1860. *Willmore's New Guide to Windsor Castle*, Windsor

# THE PLATES

VICTORIA AND ALBERT: ROYAL PATRONS

# I

## Queen Victoria, 15 May 1860

John Jabez Edwin Mayall (1813–1910)
Carbon print, printed *c.*1889–91 by Hughes & Mullins
40.2 x 30.8 cm
RCIN 2931295

Printed from a copy negative of the original albumen *carte de visite*,
made in the late 1870s (RCIN 2079258).

Following the death of William IV on 20 June 1837, the King's niece, Princess Victoria (1819–1901), became Queen. Her coronation took place on 28 June 1838. Less than two years later, on 10 February 1840, aged twenty, she married her cousin Prince Albert. Their first child, Victoria, the Princess Royal, was born on 20 November 1840, followed by Prince Albert Edward (later King Edward VII) on 9 November 1841. In all, Queen Victoria and Prince Albert had nine children, the last – Princess Beatrice – being born on 14 April 1857.

Towards the end of the 1850s, a new photographic format – the *carte de visite* – began to establish itself as a collecting craze on the commercial market in Europe. The French photographer André Disdéri (1819–89) had patented a format in 1854 which allowed eight exposures to be made on one negative plate, reducing production costs substantially. The resulting image was approximately 9 x 6 cm, pasted onto a card backing which was slightly larger than a modern business card.

Families exchanged *cartes* with each other. They also began collecting *cartes de visite* of celebrities and this quickly became a popular pastime. Queen Victoria and Prince Albert eagerly acquired *cartes* which they pasted into albums. While both had previously sat for photographers who produced portraits in the *carte de visite* format, it was not until August 1860 that photographic images of the Queen and the Prince Consort were released for sale to the public, with the Queen's permission. With the release of Mayall's photographs, images of the royal family became collectible items. For the first time, the public were able to acquire a photograph of the monarch. When the royal couple sat for Mayall in May, numerous variations of each portrait were produced. Some – including this portrait of the Queen – do not appear to have been published at the time.

This photograph is a copy of one of Mayall's *cartes de visite*. The Queen had many of her photographs copied and reprinted in the late nineteenth century because she was worried that they were fading. The resulting carbon prints were pasted into three albums, each bearing the title 'The Catalogue of the Queen's Private Negatives'.

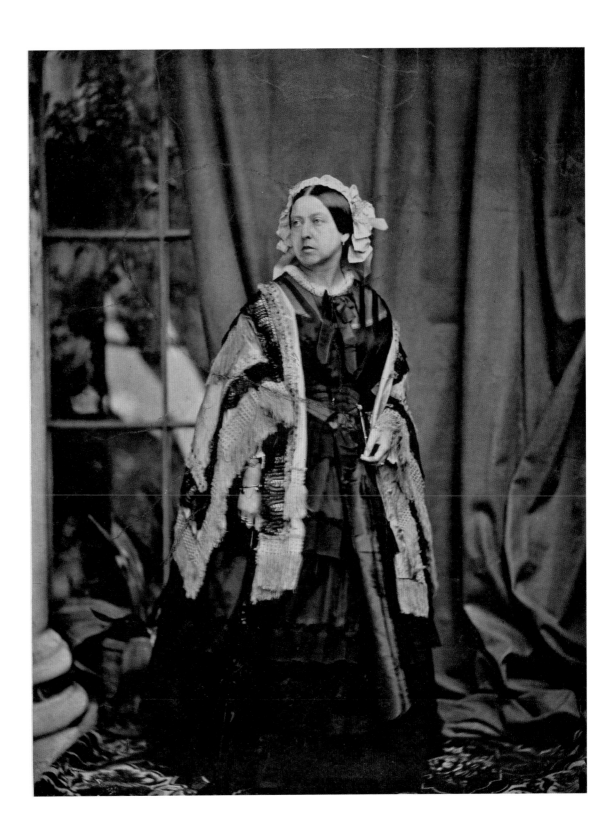

**2**

## Albert, Prince Consort, 15 May 1860

John Jabez Edwin Mayall (1813–1910)
Carbon print, printed *c.*1889–91 by Hughes & Mullins
40 x 28.5 cm
RCIN 2931343

Printed from a copy negative of the original albumen *carte de visite*,
made in the late 1870s (RCIN 2079259).

Prince Albert (1819–61) was born on 26 August 1819, the second son of the Duke of Saxe-Coburg and Gotha. The Prince first met his cousin Princess Victoria in England on 18 May 1836, following the match-making efforts of their mutual uncle Prince Leopold (later King of the Belgians). They did not meet again until October 1839. This meeting was swiftly followed by their engagement, and then their marriage on 10 February 1840.

Mayall photographed the royal family for the first time in 1855. The Queen wrote about the encounter in her journal: 'from 10 to 12 was occupied in being photographed by Mr Mayall who is the oddest man I ever saw, but an excellent photographer. He is an American & a tremendous enthusiast in his work' (Journal, 28 July 1855).

The Queen was mistaken in believing him to be an American; Mayall had been born in Oldham, Lancashire, according to the information he gave in the 1861 census. Around 1842, he moved to the US, establishing himself as a daguerreotypist in Philadelphia before returning to England in mid-1846.

He set up a business in London, and soon became one of the leading photographers in the country. He exhibited over 70 daguerreotypes in the 1851 Great Exhibition. Between 1855 and 1867, he photographed the royal family on several occasions, as well as providing numerous painted photographic portraits.

An invoice submitted in March 1863 includes charges for this portrait of Prince Albert and that of the Queen (plate 1). Although on the invoice Mayall dates the sitting to 10 May 1860, the occasion is not mentioned that day in the Queen's journal. On 15 May, however, she described a photographic session: 'Occupied for some time by Mayall taking photographs of us & very successful ones' (Journal, 15 May 1860). It was presumably the perceived success of these portraits that led to the significant decision on the part of the Queen to allow some of the photographs to be published. Mayall, on the invoice, described them thus: 'sundry *cartes de visite* prints from negatives sanctioned for publication & sundry negatives for Her Majesty's private use' (RA PPTO/PP/QV/PP2/71/5146).

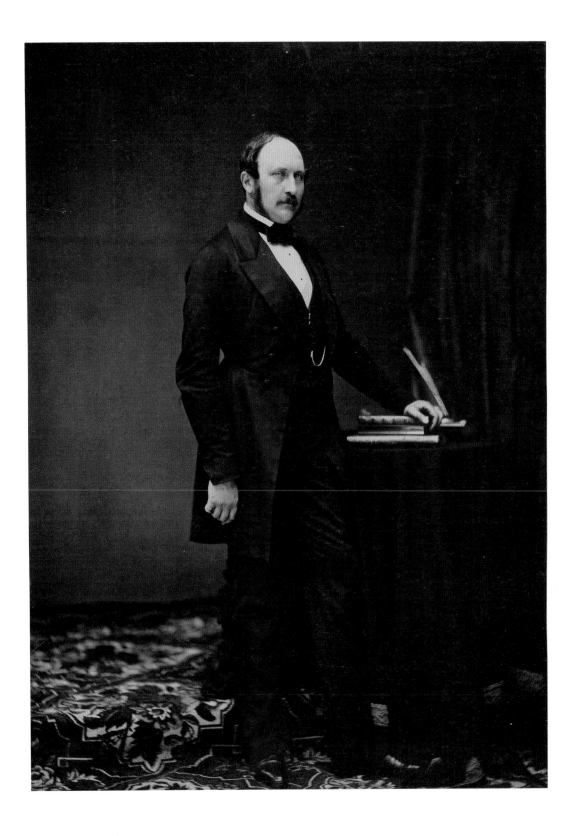

# ROGER
# FENTON

## (1819–1869)

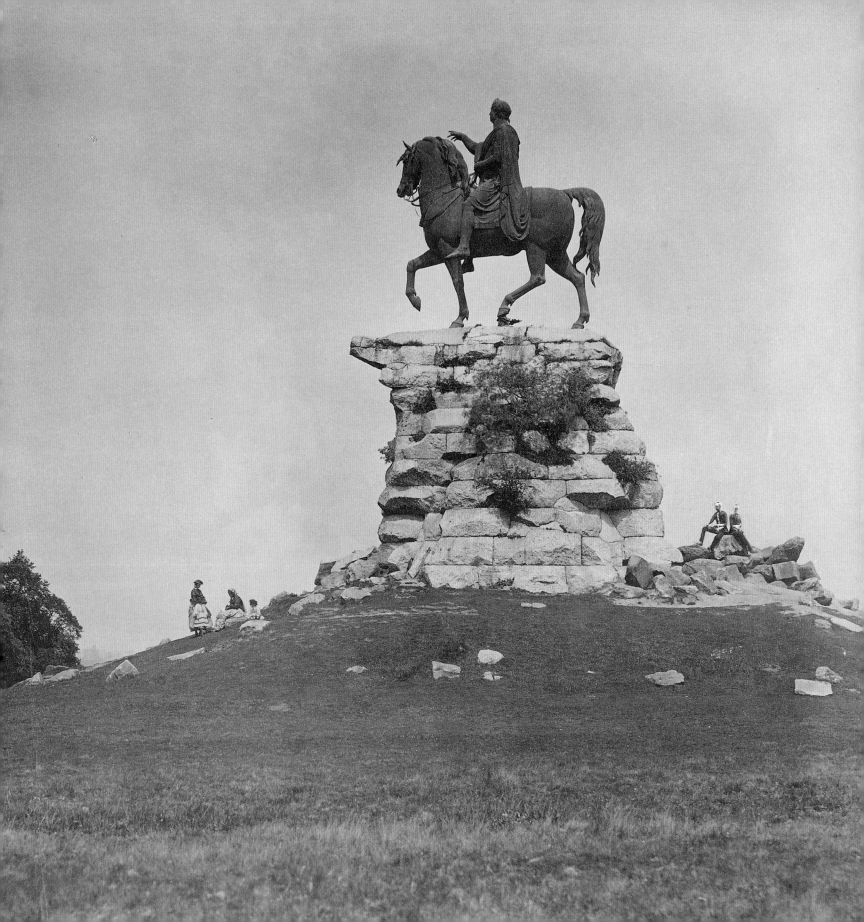

# 3

## The Princess Royal and Princess Alice, Balmoral, 1856

Albumen print
34.6 x 28 cm
Photographer's credit lithographed on the mount:
*Photographed by R. Fenton*
RCIN 2941850

The Princess Royal (1840–1901), known to her family as Vicky, was the Queen's eldest child. She is seated on a bench next to her sister Princess Alice (1843–78), the Queen's third child and second daughter.

Fenton made at least two portraits of the Princesses together at this time. A variant print and its original wet collodion glass negative are in the Royal Collection (RCIN 2941851 and negative RCIN 2079264, see p. 64). Another print of this photograph was overpainted by the artist James Roberts (c.1800–67) and, according to an entry in an inventory book made c.1870, it was displayed in Prince Arthur's sitting room in Windsor Castle (Richard Redgrave, Catalogue of Pictures the Property of Her Majesty now at Windsor Castle, 1859–75, inv. no. 904). The painted photograph is dated 1855 on the reverse. Consequently the photograph has been traditionally dated to 1855, and located at Osborne, but that date appears to be incorrect.

In 1855, Fenton was in the Crimea until his return on 11 July, leaving little time to take these photographs that year. Queen Victoria was at Osborne between 10 July and 17 August and again between 28 August and 5 September. It is possible that Fenton was received there by the Queen after his return; she wrote in her journal that she had seen 'some most interesting photos, taken by Mr Fenton, in the Crimea' (Journal, 8 August 1855). There is no mention of a meeting, however. Even if Fenton had visited, on 8 August Princess Alice was in isolation because she had contracted scarlet fever. The Queen's journal makes it clear that the Princess was not in close contact with anyone until after 29 August.

By 7 September Fenton was in Paris to show his work to Emperor Napoleon III; the Queen and her family had left for Balmoral. It is more probable that the portrait dates to 1856, and that it was taken while Fenton was at Balmoral during the autumn. The Queen was accompanied by only five of her children on the 1856 visit, and it is probable that all of them were photographed by Fenton at this time (see plates 4 and 5). The trellis and sash window behind the Princesses correspond with the gardener's cottage at Balmoral, as seen in a watercolour from September 1852 by William Wyld (RCIN 919547). The artist Landseer stayed in the gardener's cottage during his visit to Balmoral in 1850 and it may have been where Fenton stayed in 1856.

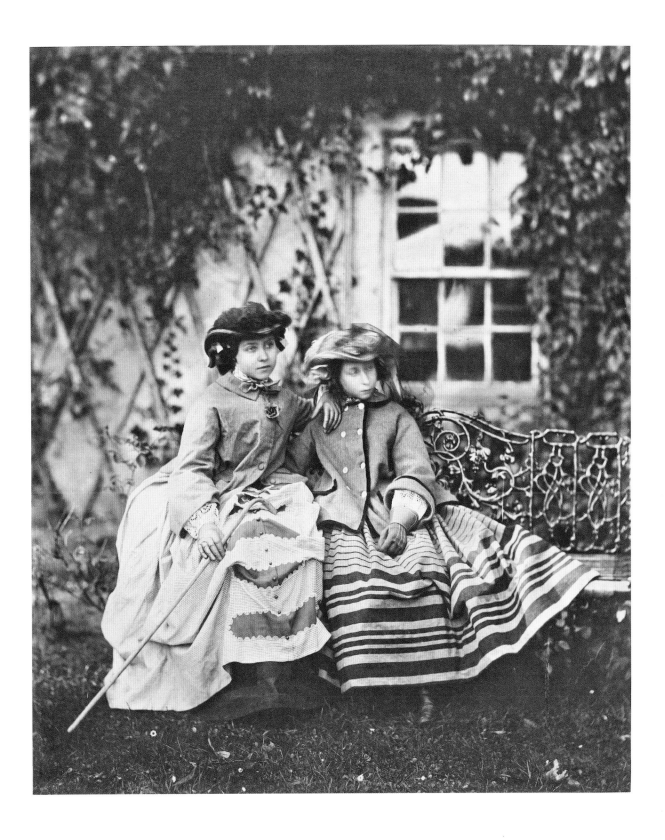

# 4

Princess Helena and Princess Louise, Balmoral, 1856

Albumen print
34.5 x 29.1 cm
Photographer's credit lithographed on the mount:
*Photographed by R. Fenton*
RCIN 2941852

Princess Helena (1846–1923) was the fifth child and third daughter of Queen Victoria. She stands on the left of the photograph, next to her sister Princess Louise (1848–1939).

In the autumn of 1856, Fenton set out on the long journey north to Balmoral to photograph the castle and members of the Queen's household. The Queen and Prince Albert had purchased the lease of the old castle in 1848 and, after the realisation that they had found an ideal retreat in the Highlands, they bought the estate outright in 1852. In 1853, they set about building a new castle alongside the existing structure. When the royal family arrived in September 1855, the new building was ready for them to occupy. One of the first significant events to take place at the castle was the engagement of the Princess Royal to Prince Frederick William of Prussia (later Emperor Frederick III of Germany). By 1856, the building work was complete and the old castle was demolished. Fenton's timely arrival coincided with the transition to the new castle.

During September, Fenton took a number of views of the castle as well as several portraits. At least two of these (of the south side of the castle; and of a group of highland servants, or 'gillies') were exhibited at the Photographic Society of Scotland exhibition, which opened in December 1856.

Fenton also travelled around the area, producing additional Scottish scenes, some of which were exhibited with at least one view of Balmoral in January 1857 at the Photographic Society exhibition in London. In 1857 he submitted an invoice to the Queen which listed '8 Negatives taken at Balmoral at £5 5s' and a further eight 'large photographs, Scotch' (RA PPTO/PP/QV/PP2/22/7526). Fenton's views of the castle show evidence of the recently completed building work, with rubble lying in front of the main façade.

The portraits of the royal children do not appear to have been exhibited or sold publicly. The original negatives for most of the portraits survive in the Royal Collection, as well as the negative for a portrait of a gillie (RCIN 2079280), suggesting that the Queen wished to retain control over the images.

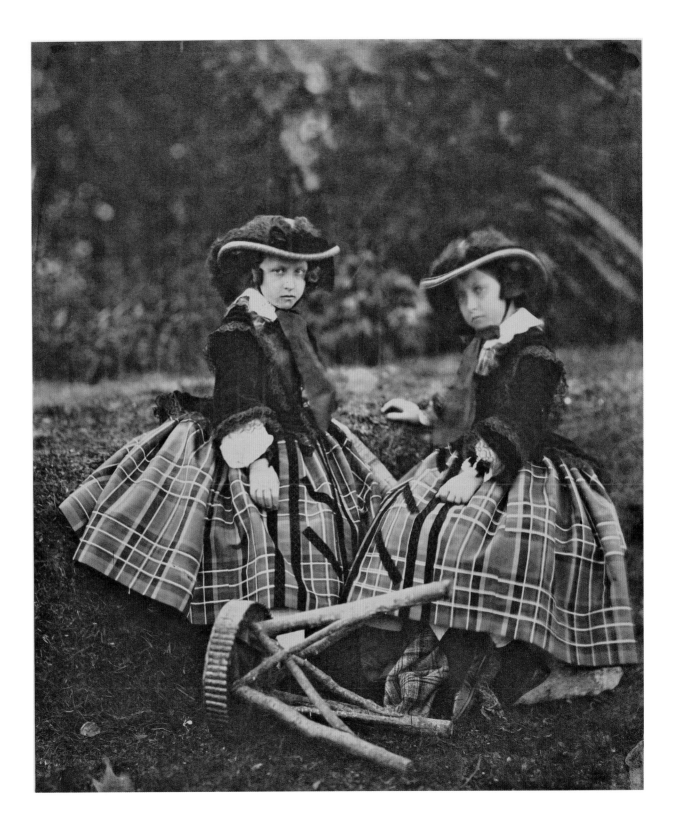

5

Prince Alfred, Balmoral, 1856

Albumen print
31.2 x 26.1 cm
Photographer's credit lithographed on the mount:
*Photographed by R. Fenton*
RCIN 2941853

Prince Alfred (1844–1900), often known in the family as 'Affie', was the fourth child and second son of Queen Victoria and Prince Albert. Destined for a successful naval career, he was sent away in 1856 to begin his training; this photograph would have been taken shortly before his departure. In 1856 the Queen was at Balmoral from 30 August until 14 October. She was accompanied by Prince Albert and five of the children; the Prince of Wales and Princes Arthur and Leopold remained at Windsor.

Fenton made at least two negatives showing Prince Alfred lying on the grass in his kilt. The first, seen here, shows him holding a walking stick. The second image (RCIN 2931417a, and its corresponding original negative RCIN 2079328) shows the Prince lying on a rock similar to or perhaps the same as the small white boulder that appears in Fenton's portrait of a gillie. As with the overturned stool in plate 4, the walking stick and rock are compositional devices, anchoring the individual to the ground as well as providing textural variation within the image. This demonstrates the care that Fenton took over the composition of the portraits.

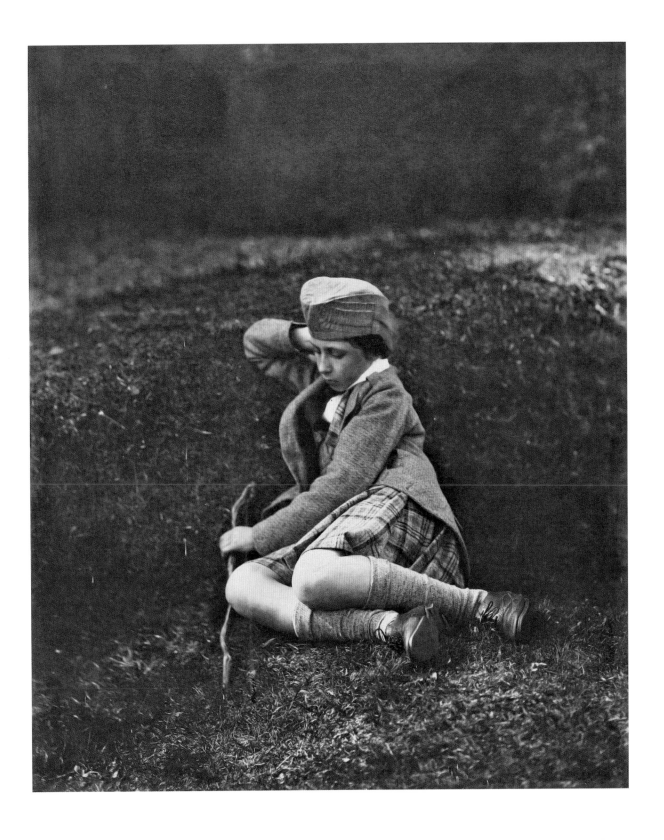

# 6

'Interior view; the round tower', Windsor Castle, 1860

Albumen print
33.1 x 43.5 cm
Photographer's credit lithographed on the mount:
*Photographed by R. Fenton*
Numbered on the mount in pencil: *No 61*
RCIN 2100046

In the summer of 1860, Fenton photographed Windsor Castle and the surrounding parkland, producing a series of at least 31 separate views. The photographs include a number of landscape studies in the Home Park and Great Park as well as architectural views taken within the Castle walls.

This particular view was taken in the Lower Ward, looking up towards the Round Tower, with St George's Chapel on the left. Two soldiers, both from the Coldstream Guards, stand prominently on the pathway, looking at the camera and reminding us that the Castle was then – as now – a fully occupied royal residence with a military guard.

In producing a series of views of the royal fortress for publication, Fenton was following an established precedent. Windsor Castle (and other royal residences) had been documented previously by artists including Paul Sandby, William Daniell, Joseph Nash and J.B. Pyne. Nash's watercolours, made in 1844–6, were published as lithographs in *Views of the interior and exterior of Windsor Castle,* 1848, with a dedication to Queen Victoria. The views were evidently popular; a second edition was produced in 1852 and a miniature edition followed in 1863. The market for views of the Castle was perhaps encouraged by the success of Harrison Ainsworth's novel *Windsor Castle. An Historical Romance* (1843), illustrated by George Cruikshank.

Some of Fenton's photographs of exteriors are similar to those created by Nash. It is possible that Fenton knew of Nash's lithographs, but as a trained artist with several years of architectural photography behind him, he was capable of composing an aesthetically accomplished photograph within the picturesque tradition.

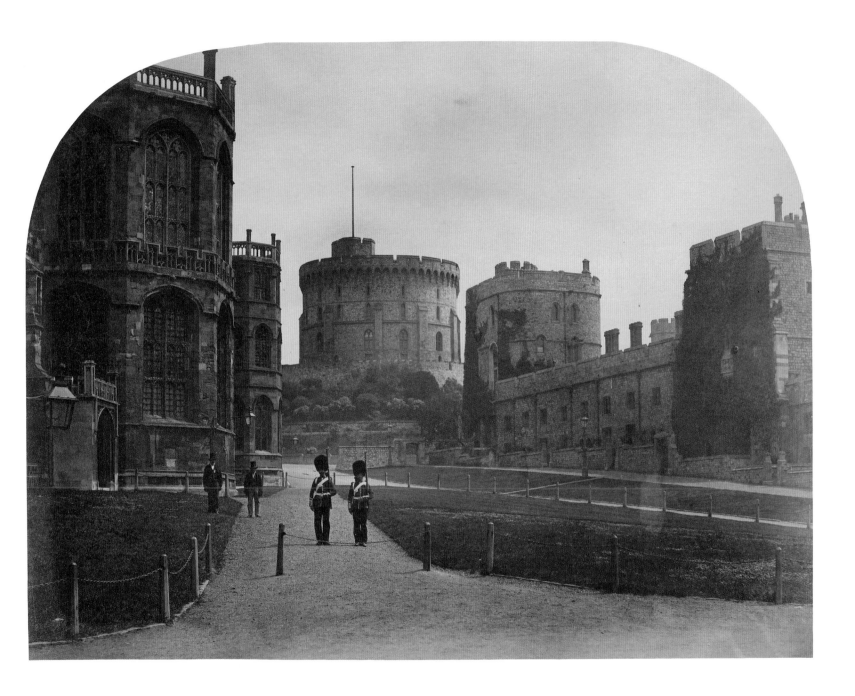

# 7

## 'The north side', Windsor Castle, 1860

Albumen print
34.9 x 41.9 cm
Photographer's credit lithographed on the mount:
*Photographed by R. Fenton*
Numbered on the mount in pencil: *No 54*
RCIN 2100062

This view, of the north front of the Castle from the Slopes in the Home Park, was taken in an area of the grounds not normally accessible to the public at this time. A guidebook published in 1860, described the area: 'The ground forming the declivity of the hill on the North Terrace of the Castle was enclosed in the late reign, and converted into an extensive garden, the walks of which are planted with a variety of shrubs, interspersed with parterres of flowers and sheltered with plantations of forest trees. This portion of the Park is termed from its situation on "The Slopes", and communicates with the North Terrace. The public were admitted to it till 1823, when George IV, taking up his residence at the Castle, withheld this indulgence' (Willmore 1860, pp. 20–1). The area of the Home Park shown here and in plate 8 had also benefitted greatly from Prince Albert's attention in the 1840s (Roberts 1997, p. 192).

Although there had been a castle on this site from 1070, by the mid-eighteenth century it had become very run-down. Restoration works were begun in the reign of George III, but it was George IV who was responsible for renovating and transforming the Castle into a worthy setting for elaborate royal ceremonies. After George IV began to use the Castle, certain areas were closed to the public. It was possible to apply to the Lord Chamberlain for permission to visit some of the restricted areas of both the park and the Castle during the times when the Court was not in residence. The guidebooks recommended instead a visit to W.F. Taylor's Library on the Windsor High Street where views painted by Johan Paul Fischer of 'the Private Pleasure Grounds known as the Slopes' were on display to the public for a small fee (Taylor c.1856, p. 23).

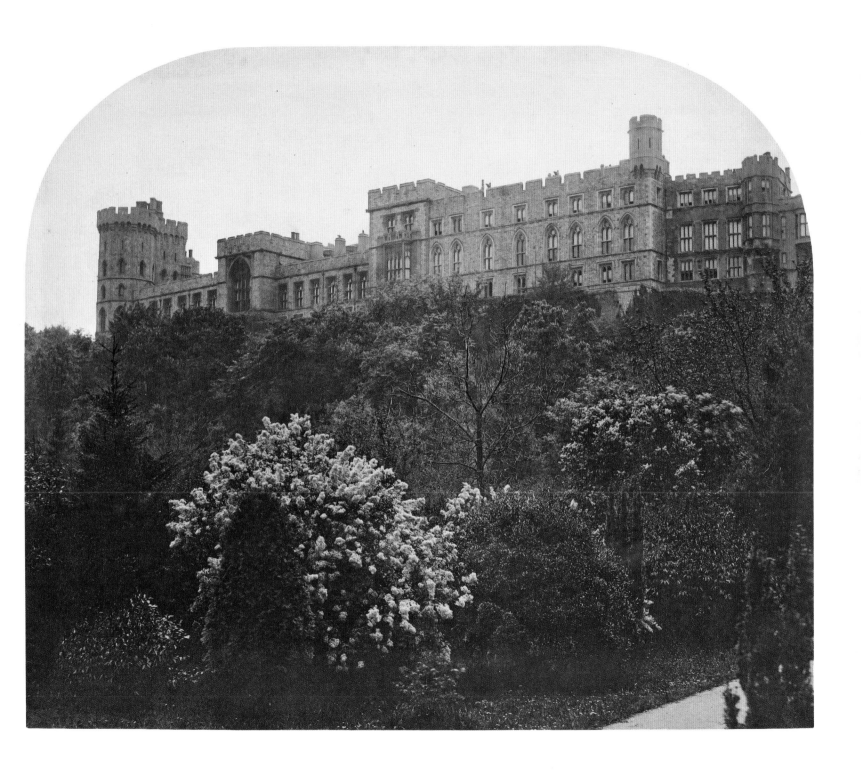

# 8

'View on the slopes', Windsor Castle, 1860

Albumen print
34.5 x 42 cm
Photographer's credit lithographed on the mount:
*Photographed by R. Fenton*
Numbered on the mount in pencil: *No 56*
RCIN 2100067

In this view, only a small part of one of the Castle's towers is visible; the rest of the Castle is obscured by the foliage of the trees. Fenton's architectural studies demonstrate that one of the photographer's concerns was to place the building he was photographing in its wider context. It was not unusual for the context to become more prominent than the building itself. The resulting image is redolent of the rich fullness of high summer.

Fenton took a number of views of the Slopes, which provided highly picturesque material for the composition of photographs. As a contrast to this view, which presents the pathway at an angle, Fenton also photographed an avenue through the Slopes which extends away from the viewer in a straight line. Its strong graphic qualities contrast with the picturesque element within this scene. Another view in the series shows one of the trees – an Indian deodar – planted by Queen Victoria on the Slopes.

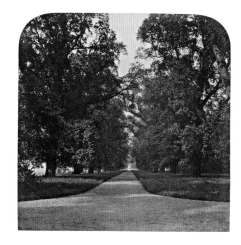

Roger Fenton, *Avenue in the Slopes, 1860*; albumen print (RCIN 2100069)
28.4 x 28.7 cm

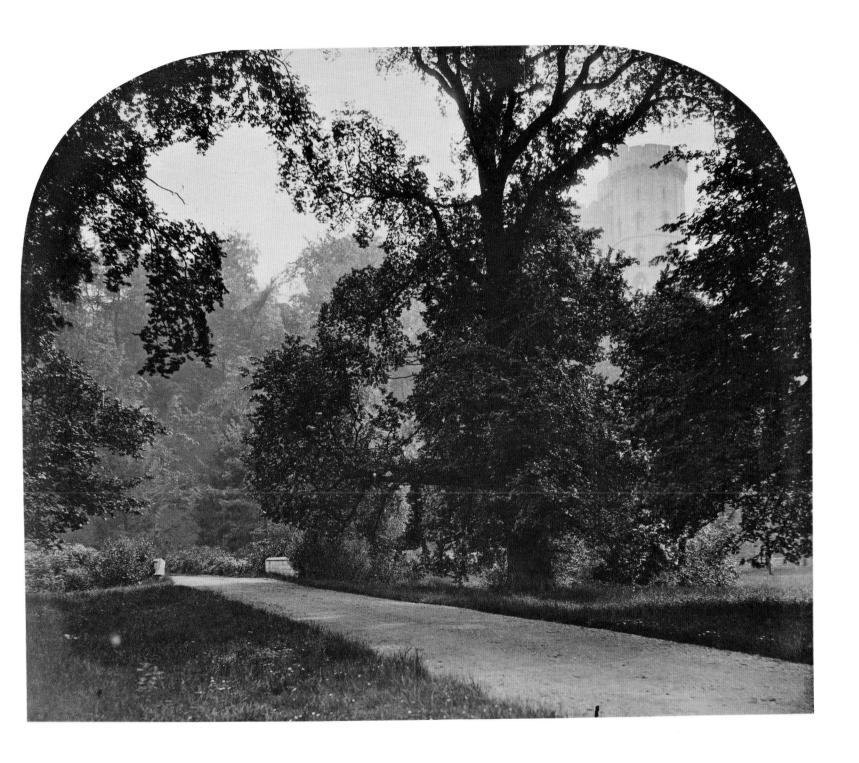

# 9

'The long walk', Windsor, 1860

Albumen print
31.8 x 42.3 cm
Photographer's credit lithographed on the mount:
*Photographed by R. Fenton*
Numbered on the mount in pencil: *No 65*
RCIN 2100071

The Long Walk was planted in the early 1680s during the reign of Charles II. It was laid out to run along an axis which extends due south from the centre of the south front of the Castle as far as Snow Hill in the Great Park, a distance of around two and a half miles (approximately four kilometres). Fenton's dramatic photograph makes full use of the avenue which stretches northwards towards the Castle. The Castle itself is only just visible in the distance, but this image shows both George IV's 1820s transformation of the Castle, and its sumptuous surrounding park to great advantage. The equestrian statue of King George III (plate 10) is immediately behind the photographer.

A single female figure, perhaps Fenton's wife Grace, stands at the top of the walk with her back to us. On the other side of the walk is a sign providing information about access to the area. It begins with the initials 'V R' for *Victoria Regina* (Queen Victoria).

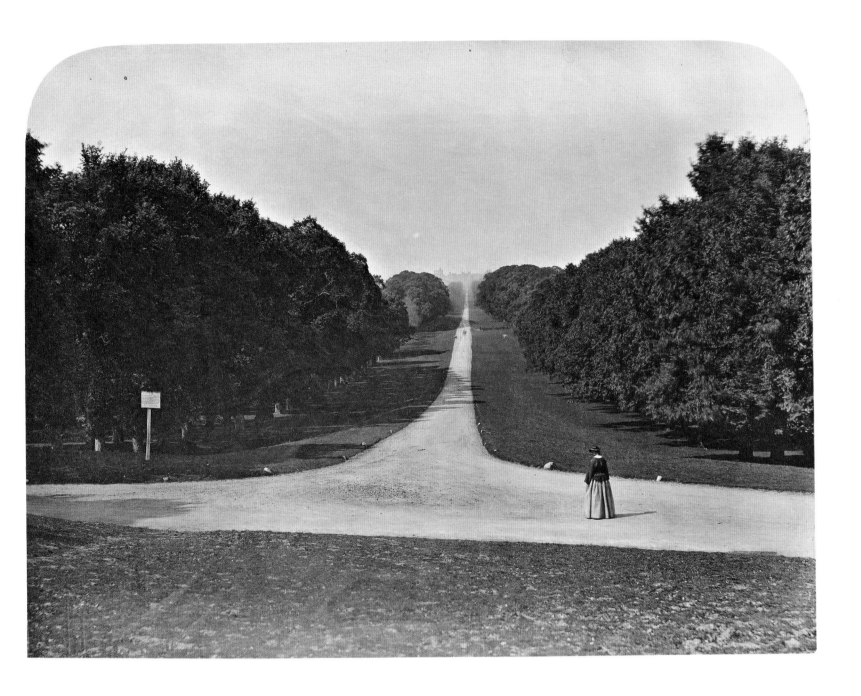

# 10

'Statue of Geo 3rd, the long walk, Windsor', 1860

Albumen print
29.8 x 42.7 cm
Photographer's credit lithographed on the mount:
*Photographed by R. Fenton*
Numbered on the mount in pencil: *No 64*
RCIN 2100072

The statue of George III was erected at the end of the Long Walk by his son George IV, to commemorate his father at Windsor. George III had been active in making improvements in the park, particularly at the north end where the statue stands. It was the work of the sculptor Richard Westmacott (1775–1856).

The statue was cast by October 1828 but the construction of the massive plinth caused some delay. The design and execution of the supporting plinth lay with Jeffry Wyatville (1766–1840), the architect responsible for the renovations and additions made to Windsor Castle for George IV. The plinth contains a plaque with the inscription *Georgio Tertio Patri Optimo Georgius Rex* (George III – Best of Fathers – King George [IV]). By mid-1831, a granite plinth with an irregular design supported by a brickwork foundation was completed, and the statue was elevated on 24 October 1831.

The statue is usually referred to as the Copper Horse, although it consists of an iron frame clad in bronze. It shows George III on horseback, with his right arm gesturing towards Windsor Castle, his favourite residence. The outline of the Castle, in particular the Round Tower (plate 6), can be seen in the distance in Fenton's photograph. The statue remains a notable landmark today.

In the photograph, Fenton has placed two groups of figures on either side of the plinth. Three women are situated to the left, while two soldiers sit on the stones to the right. In the Windsor series, Fenton produced a variant of this image from a smaller negative (21 x 29 cm) in which the women remain, but the soldiers have disappeared (RCIN 2100073).

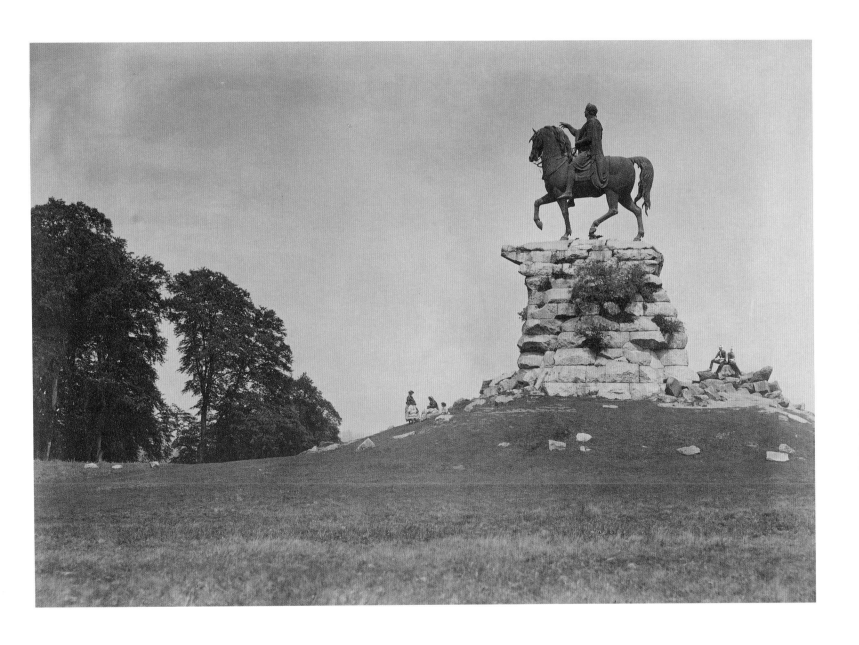

# 11

'View across the park', towards Windsor Castle, 1860

Albumen print
23.9 x 43.2 cm
Photographer's credit lithographed on the mount:
*Photographed by R. Fenton*
Numbered on the mount in pencil: *No 67*
RCIN 2100074

The silhouette of the Castle, particularly the Round Tower, can be seen in the distance. The Long Walk is hidden by the trees on the right of the photograph. This area of the Great Park was (and still is) home to a herd of deer, a feature that was noted in many guidebooks of the time: 'The Great Park, the scenery of which is both varied and picturesque, contains about 1800 acres, and is stocked with several thousand head of fallow deer. It lies on the south side of the town, and is intersected by several roads, the principal of which is the Long Walk' (Willmore 1860, p. 23).

Fenton shows the Castle to great effect in its surroundings, presenting a peaceful landscape, the expansive horizon hazy from the summer heat. By 1860, the number of visitors coming to Windsor had increased dramatically, however, and peacefulness was perhaps unlikely during the summer months.

The arrival of the railway with the opening of two stations in Windsor in 1849 meant that the journey to Windsor was easy and economic, encouraging many more tourists. The existence of cheap guidebooks, including some in French, suggests that the journey was a popular trip from the capital. The increased number of visitors meant that there was a larger audience for views of the town and Castle, something which may have encouraged Fenton to produce such an extensive series. By 1862, Windsor's enterprising bookseller and stationer W.F. Taylor was advertising 'a great variety of Photographic Views of the Castle and St. George's Chapel' for sale. Taylor also sold a large number of lithographs and books on Windsor, as well as a 7-foot-long panorama of the Castle (back cover advertisement, Taylor 1862).

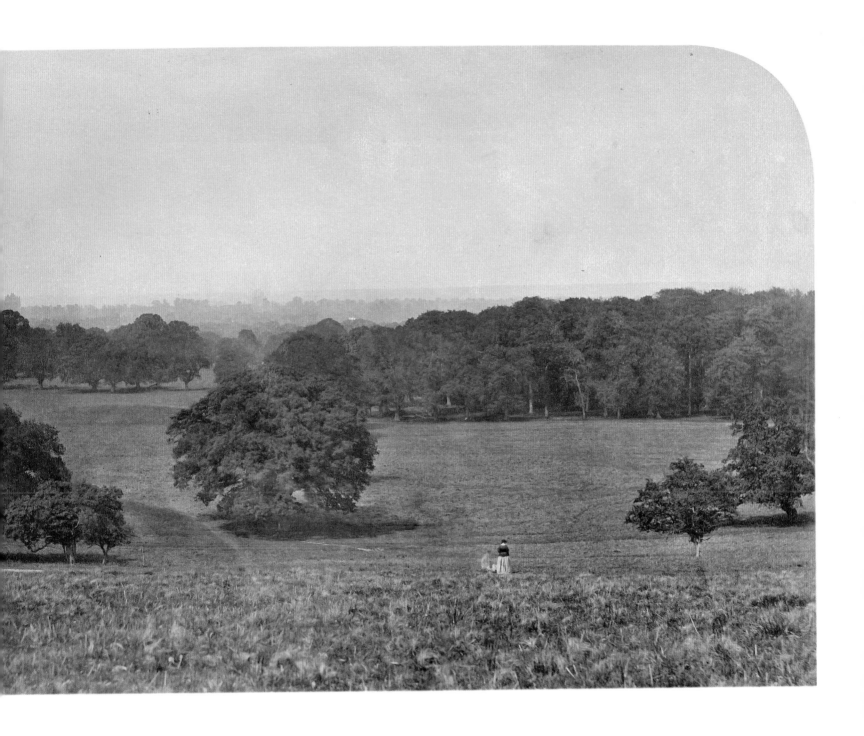

# 12

'The Whitworth Rifle fired by the Queen at Wimbledon, July 2, 1860'

Albumen print
25.3 x 28 cm
Photographer's credit lithographed on the mount:
*Photographed by R. Fenton*
Numbered on the mount in pencil: *No 8*
RCIN 2941854

The National Rifle Association was formed in 1859 out of the various Volunteer regiments that were emerging across the country in response to the possibility of war with France. The association was to provide a forum for promoting and encouraging rifle-shooting and, as part of this, an annual meeting was established with competitions and prizes to set higher standards. The first meeting, which lasted for six days, was held on Wimbledon Common, with Queen Victoria inaugurating the event.

The Queen subsequently wrote about the occasion in her journal: 'We went over the new suspension bridge, through Battersea Park, Wandsworth & Wimbledon, through Wimbledon Park (Ld Spencer's property) on to the Common, where there was an immense concourse of people. George [the Duke of Cambridge], with the Committee, at the head of which were Mr S. Herbert, Ld Spencer, & Ld Elcho, the most active members, received us at the entrance of a fine large tent, through which we walked. ... We received Addresses, read by Mr S. Herbert & afterwards walked up the line to another small tent, where the Rifle was fixed by Mr Whitworth himself. I gently pulled a string & it went off, the bullet entering the bull's eye at 300 yards!!'[1]

Ld Elcho gave me the medal. We then returned to the big tent, remaining there some time, the Bands playing, while the shooting began. We also visited a tent, with new rifle inventions.' (Journal, 2 July 1860; see also plate 13)

The Whitworth rifle was invented in 1859 by the engineer Joseph Whitworth (1803–87) as a possible replacement to the Enfield rifle, which had revealed many shortcomings during the Crimean War. It was still new and relatively unknown at the time of the meeting. The rifle that was fired by the Queen – and the target she shot – have been preserved by the National Rifle Association.

1   The Queen wrote in her Journal that the distance to the target was 300 yards, but all other reports give it as 400 yards.

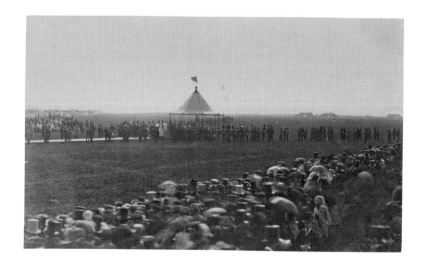

Roger Fenton, *Her Majesty firing the first shot, Wimbledon, July 1860*; albumen print (RCIN 2935160) 16.7 x 28 cm

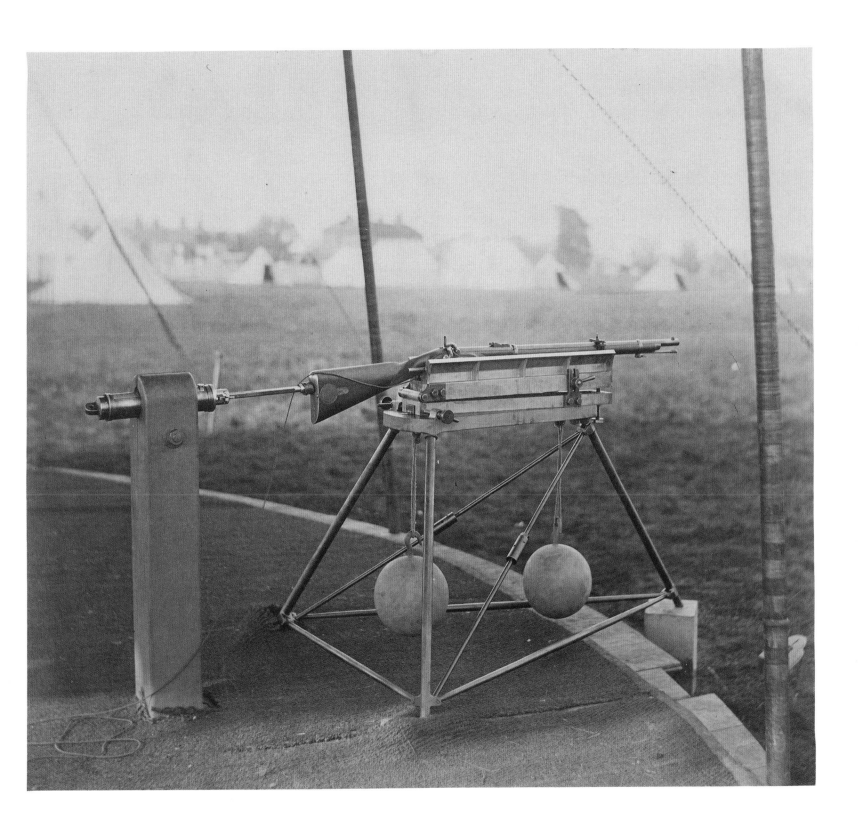

# 13

'The Queen's target', 2 July 1860

Albumen print
34.6 x 28 cm
Numbered on the mount in pencil: *No 10*
RCIN 2941855

In 1861, the move to replace the Enfield rifle, commonly used by all British troops, was discussed in the House of Commons. Lord Vivian, speaking as a member of the Select Committee on the matter, made a case for the Whitworth rifle: 'The House would remember that when, at the contest for the prizes, Her Majesty was about to fire the first shot, the rifle was mechanically fixed. The shot was fired from the Whitworth rifle, and it not only struck the bull's eye, but was only an inch and a half from the centre. Considering that the shot was calculated beforehand, and that it was fired in the open air and at a distance of 400 yards from the target, it was probably the most marvellous shot that ever came from a rifle.' (Hansard 1861, vol. 163, cc. 1562–83)

The meeting had been widely reported in national and international newspapers in July 1860. Apart from the 360 competitors, as many as 15,000 spectators were said to have been present when the Queen fired the rifle.

After the Queen had hit the bull's eye, an artist ran across to sketch the exact position of the bullet hole in order to show the Queen. Upon being handed the sketch by Prince Albert, the Queen laughed and then asked to see the actual target. It was however made of solid iron and required a number of men to carry it. So, the newspapers reported, it was decided that a photograph of the target would be taken instead.

Both the fixed rifle and the target were put on display in the Royal Pavilion during the meeting and members of the public were charged a shilling to enter.

The simplicity and directness of this composition make it a dramatic and unusual photograph, commemorating an event that caught the public imagination. By concentrating so closely on the target, Fenton changes the photograph from a record of an event, into a strikingly abstract image.

# 14

'Shooting for the Duke of Cambridge's Prize, Wimbledon', 2 July 1860

Albumen print
23.7 x 29 cm
Photographer's credit lithographed on the mount:
*Photographed by R. Fenton*
Numbered in pencil on the mount: *No 12*
RCIN 2941856

Prince George, Duke of Cambridge (1819–1904), was a grandson of King George III and a first cousin of Queen Victoria. At the time of the National Rifle Association meeting, he was the Commander-in-Chief of the British army. Although he had a reputation for being somewhat resistant to change, he was keen to investigate the possibilities of breech-loading rifles as weapons for use by the military. Breech-loading weapons are reloaded at the rear of the barrel, rather than at the muzzle-end, thus reducing the reloading time considerably.

The Duke, who attended the meeting on the first day as part of the royal party, instituted a prize of £50 for breech-loading rifles not exceeding 10 lbs, at ranges of 800, 900 and 1,000 yards. The prize was won by a Swiss rifleman called Knecht who shot with a Westley-Richards rifle (a design made under licence from Joseph Whitworth). The following year, the Duke was responsible for trialling the Westley-Richards within various sections of the army.

# 15

'Mr Ross Junr., the winner of the Queen's prize', July 1860

Albumen print
25.3 x 21.8 cm
Photographer's credit lithographed on the mount:
*Photographed by R. Fenton*
Numbered in pencil on the mount: *No 21*
RCIN 2935167

This portrait of nineteen-year-old Edward Charles Russell Ross (1841–96) was taken at 2 Albert Terrace, on the edge of Regent's Park in London, Fenton's family home since December 1847. At the National Rifle Association meeting, Ross had been the winner of the Queen's Prize – a competition set up with the intention that it would become the most prestigious shooting award for riflemen. Ross had taken up shooting at the age of five, encouraged by his father Horatio Ross (1801–86), the latter being regarded as one of the most accomplished marksmen of the Victorian age (see plate 16). At the time of the competition, Edward was a member of the 7th (North Yorkshire) Volunteers and about to go up to Trinity College, Cambridge, to study law.

The prize was open only to Volunteers, and the winner received £250. Each competitor had five shots at each of the five distances of 800, 900 and 1,000 yards. Ross was to win in a class of 36 competitors, with a total of 24 points. *The Times* newspaper reported that, when accepting the prize, Ross was greeted by the band playing 'See the conquering hero comes' (*The Times*, 10 July 1860).

Ross established a successful career in London as a barrister. He continued to keep up his rifle skills throughout his life, every year attending the meeting of the National Rifle Association.

'H. Ross & Son, the teacher & pupil', July 1860

Albumen print
26.3 x 24.8 cm
Photographer's credit lithographed on the mount:
*Photographed by R. Fenton*
Numbered in pencil on the mount: *No 23*
RCIN 2935168

Edward Ross is photographed here at Albert Terrace with his father Horatio Ross (1801–86), one of the most accomplished sportsmen of the nineteenth century. Horatio Ross was present for the rifle meeting on Wimbledon Common but he had met Fenton at least once before: the two men were in the Volunteers in 1860 and Fenton photographed Ross with his comrades during training in February (see pp. 10–11). It is not surprising that they should have become better acquainted for Horatio Ross was a pioneering photographer, having made daguerreotypes in Scotland in the 1840s before adopting the calotype process and subsequently the wet collodion process (that used by Fenton).

Ross played a prominent role in the Photographic Society of Scotland, as Vice-President in 1856 and two years later as President. He exhibited examples of his work widely in the 1850s, including a large number of photographs at the society's 1856 and 1858 exhibitions in Edinburgh. The majority of his work was related in some way to photographing aspects of deer stalking, but he also made architectural and landscape studies as well as a few portraits.

Ross was born in Rossie, in Forfarshire, Scotland, and was named after Horatio Nelson, his godfather. During the 1820s he was active as a sportsman, before turning to politics in the 1830s. He served as a Member of Parliament between 1831 and 1834. Ross continued to be involved in the Volunteer movement throughout his life and was an active rifleman, encouraging all his sons in the sport.

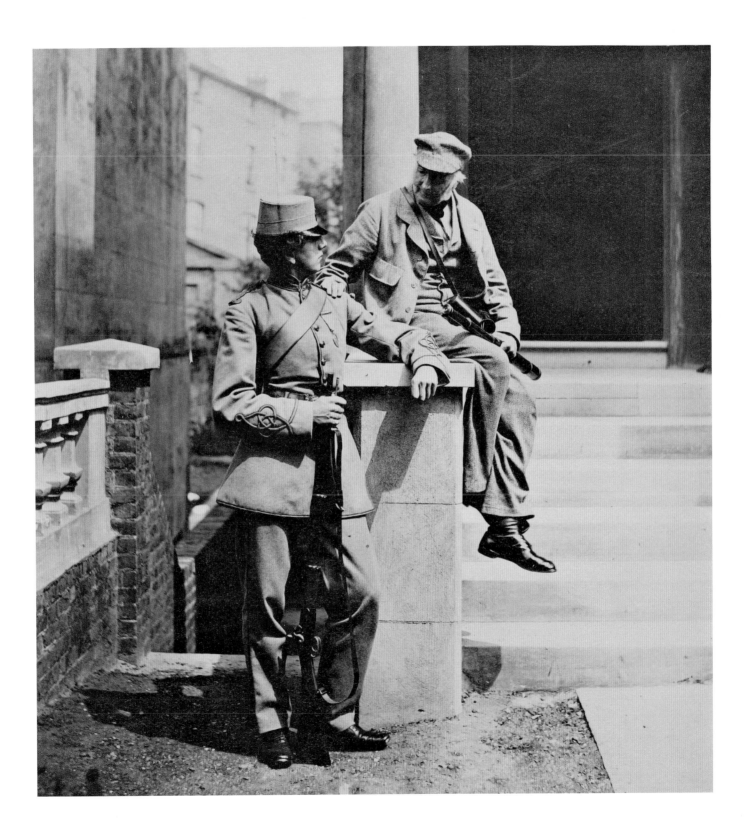

JULIA MARGARET
# CAMERON
(1815–1879)

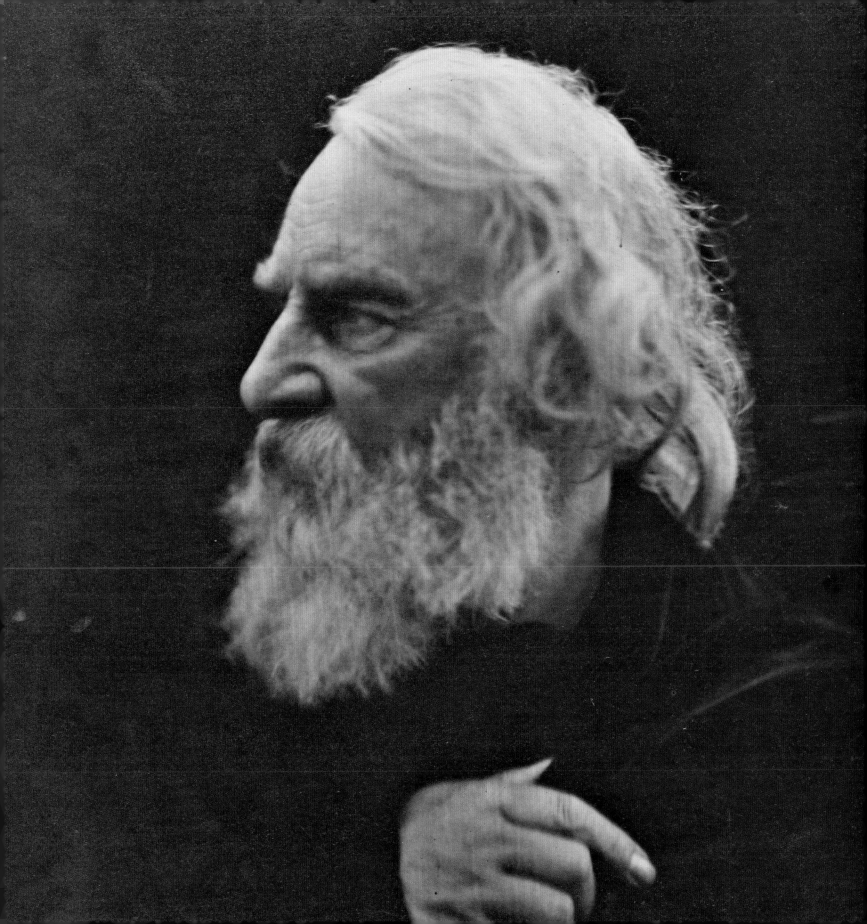

# 17

'Clinton Parry Esqre', 1868

Albumen print
30.9 x 25.6 cm
Signed and dated in ink: *Julia Margaret Cameron From Life Fresh Water 1868*
In an unknown hand: *Eldest son of T. Gambier Parry of Highnam*
*Co Glouc & brother of Sir C. Hubert Parry*
With Colnaghi blindstamp
RCIN 2941857

Charles Clinton Parry (1840–83) was the eldest son of Thomas Gambier Parry, a patron of the arts and an accomplished artist in his own right. He grew up at Highnam Court in Gloucestershire with his younger brother Hubert (1848–1918), who became a composer and is best known today for the hymn 'Jerusalem' (1916).

From an early age Clinton showed great academic promise. He went up to Oxford University in 1859 and studied for degrees in both music and history. He began to display signs of instability, however, including excessive drinking and drug-taking, resulting in his being sent down in disgrace. Although his father persuaded the authorities to allow Clinton to return to Oxford, in May 1863 he was sent down permanently. Shortly afterwards, he fell in love with Florence Hinde, a woman his father considered unsuitable. None of his family attended their wedding in August 1865.

Clinton's condition over the following years grew steadily worse, although there is no hint of this in Cameron's portrait, which was taken around this time. His father paid him to set up a business in Natal, South Africa, but Clinton squandered the capital and returned to England. By 1872, he was spending increasing amounts of time in hospitals and asylums. On 29 June 1880, his father sent him to New Zealand without his wife and four children, in order to avoid scandal and any harm coming to his family. Clinton worked on a sheep farm in the Wanganui Valley for a while before begging to return home. His father sent him only enough money for him to reach Australia, where he was to die in 1883.

# 18

## 'Sir John Simeon, Bart. M.P.', *c.*1868

Albumen print
34 x 26 cm
Signed: *From life Registered photograph Copyright*
*Julia Margaret Cameron Freshwater I. of W*
With Colnaghi blindstamp
RCIN 2941858

Sir John Simeon (1815–70), 3rd Baronet, lived at Swainston, near Newport, on the Isle of Wight, and served as the island's Member of Parliament for two sessions: 1847–51 and 1865–70. He was passionate about books and libraries, and was involved in publishing on a small scale. He was also a member of the Roxburghe Club, a society of bibliophiles whose membership is limited to 40 people at any one time.

Simeon was a close friend of Tennyson, whose poem *In the Garden at Swainston* includes the words 'Three dead men have I loved, and thou art last of the three', following Sir John's death in 1870. He was also one of the circle of individuals who knew the Camerons on the Isle of Wight. Cameron had only one sitting with Simeon. She left copies of the portraits for him to collect at Colnaghi in London and, in a letter dated 27 April 1868, asked him to let her know his thoughts: 'I am anxious to know if

they find favour with you and with your people and if you will write to me all you think ab[ou]t them I shall be glad. Colnaghi has nothing to do with them for they are not yet published' (quoted in Cox and Ford 2003, p. 499).

The blindstamp present on the mount of this print indicates that Colnaghi did subsequently sell copies of the photograph. Cameron registered the portrait for copyright purposes on 8 June 1870, less than three weeks after Simeon's death on 21 May 1870. She took advantage of the Copyright Act of 1862, which for the first time recognised photography as a graphic art entitled to copyright protection. The photographs were registered at Stationers' Hall, London. Between May 1864 and October 1875, 508 photographs were registered in Cameron's name (Cox and Ford 2003, p. 497). The date of registration is usually, but not always, close to the date when the photograph was made.

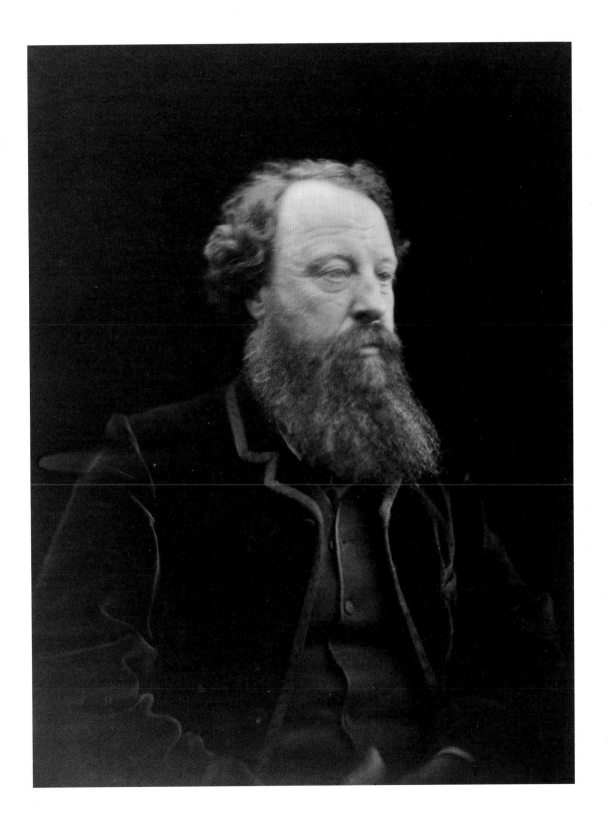

# 19

'Thomas Carlyle', 1867

Albumen print
31.6 x 24.6 cm
Signed and dated: *From life 1867 Julia Margaret Cameron*
With Colnaghi blindstamp
RCIN 2941860

This portrait, one of three different poses made by Cameron, was taken in the early summer of 1867 at Little Holland House in London. This was the home of Cameron's sister Sara, who had married Henry Thoby Prinsep. The Prinseps set out to establish their home as a meeting place for the most accomplished and significant writers, artists and politicians: one of their friends was Thomas Carlyle (1795–1881), the most celebrated historian and essayist of the nineteenth century. Carlyle's wife Jane had died the year before Cameron's portrait was taken and, as a result, Carlyle had partly withdrawn from public society.

Cameron stated that, when photographing prominent men, she intended to record 'faithfully the greatness of the inner as well as the features of the outer man' (*Annals of My Glass House*, 1874). She saw Carlyle as a great man and a great writer – a hero. In her portrait, the frame is filled entirely by Carlyle's head. All other distractions have been removed by placing him in front of a dark background, and covering his neck and shoulders with a dark cloak. It forces the viewer's attention onto the face of the sitter, with the intention that this leads to an examination and interpretation of the features and head. This portrait is also notable for the use of Cameron's 'out-of-focus' technique, something for which she was both heavily criticised and admired when she exhibited her work. Cameron wrote that although this was initially an error on her part, she soon began to adopt it as an artistic technique to help achieve a more painterly image.

The portraits of Carlyle are particularly striking, as the head exhibits a dynamism and energy that reflects the intellectual character of the man. It pushes against the boundaries of the image. In a letter dated 11 June 1867, Cameron wrote to an unidentified correspondent: 'Carlyle's photograph is more like a block of marble out of Michel Angelo's [*sic*] hands than a work out of such a <u>machine</u> as the camera so the great artists who have seen it say. The Profile Mr Jones delighted in as the most supremely beautiful thing I had ever done but it is fair to tell you Mr Carlyle does not like my Photographs of himself – The artists however insist upon giving them extreme praise Mr Millais – Gabriel Rossetti & Mr Watts all are enthusiastic about my profile of Carlyle' (Letter MS 38345, Dept of Manuscripts, St Andrews University Library).

Two years after this photograph was taken, Queen Victoria met Carlyle at a reception at the Deanery of Westminster Abbey. Writing in her journal, she described Carlyle: 'the Historian, a strange looking, eccentric old Scotchman, who holds forth in a rather drawling melancholy voice upon Scotland & the utter degeneration of everything!' (Journal, 4 March 1869)

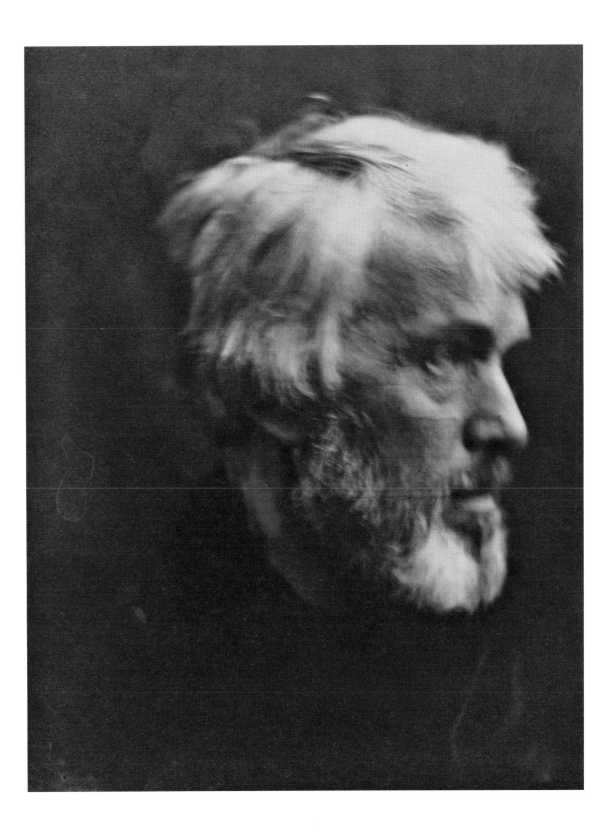

# 20

'Henry W. Longfellow', July 1868

Albumen print
35.7 x 27.5 cm
Signed and dated: *From life Registered Photograph Taken at Fresh Water Bay*
*July 1868 Julia Margaret Cameron*
Signed by Longfellow: *Henry W. Longfellow*
In unknown hand: *thirty shillings being genuine written autograph*
With Colnaghi blindstamp
RCIN 2941859

Henry Wadsworth Longfellow (1807–82) was an American poet regarded during his lifetime as a great writer and linguist. He travelled to Europe on several occasions, the first time in the late 1820s after finishing university, the last in 1868 as a famous author of many works, including *Hyperion* (1839), *Evangeline* (1847) and *The Song of Hiawatha* (1855).

Longfellow visited Tennyson on the Isle of Wight for two days in July 1868. During this time, Tennyson took his guest across to see Cameron and have his portrait made. He departed with the words: 'You will have to do whatever she tells you. I will come back soon and see what is left of you' (quoted in Cox and Ford 2003, p. 30).

During his time in England, Longfellow also had a brief meeting with Queen Victoria at Windsor Castle, which may explain why she selected this particular photograph. The Queen wrote: 'I made the acquaintance of the celebrated American Poet, Longfellow, whom Augusta Stanley brought. He is a fine looking, intelligent & pleasing old man with quite white hair & beard. He is much gratified by his reception in this country & the feeling shown by the working classes, in their anxiety to see him is quite striking' (Journal, 4 July 1868).

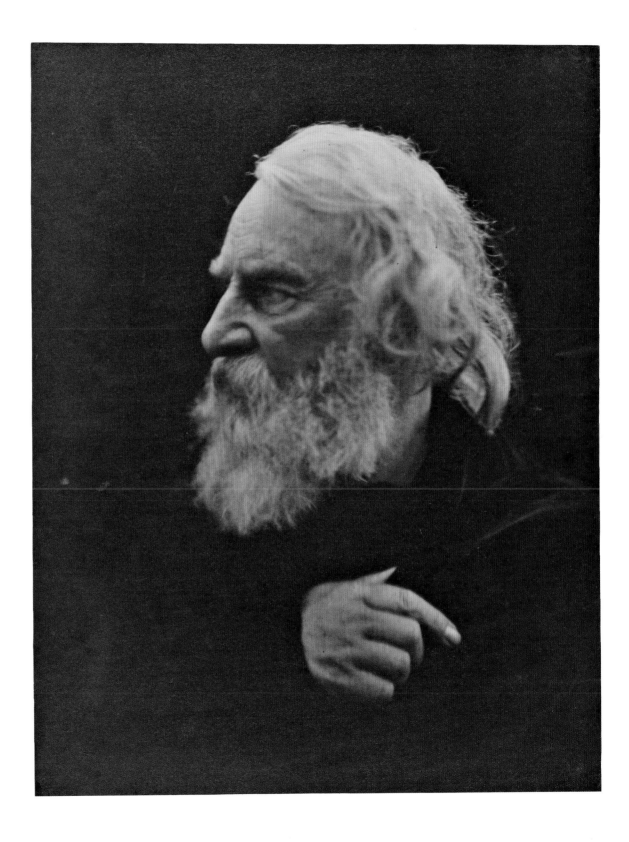

# 21

'G.F. Watts', 1865

Albumen print
36.7 x 28.9 cm
Signed and dated: *From life not enlarged Freshwater Bay Isle of Wight 1865 Julia Margaret Cameron*
With Colnaghi blindstamp
RCIN 2941861

Of all Julia Margaret Cameron's sitters, the painter George Frederic Watts (1817–1904) was probably the most influential in developing and encouraging her thoughts and ideas on art and photography. From 1850 Watts lived at Little Holland House with the Prinseps before moving with them to the Isle of Wight, and was at the heart of the artistic circle that formed around their house. He gradually conceived the idea of systematically producing portraits of the great men of the day 'whose names will be connected with the future history of the age' (quoted in Bryant 2004, p. 18). This concept coincided with the founding of the National Portrait Gallery in 1856.

Watts and Cameron corresponded energetically about their work, and their attitudes towards portraiture were strikingly similar. Both aspired to produce portraits that were works of art, expressing the individual character of the sitter rather than recording external appearances. Watts, as part of Cameron's inner circle (in addition to living with the Prinseps, he was a close friend of her neighbour Tennyson), was photographed on several different occasions.

Although Queen Victoria acquired the work of many contemporary painters – particularly Landseer, Winterhalter, Maclise and Leighton – she owned no work by Watts, despite his reputation during the nineteenth century as one of England's greatest artists. Amongst the Queen's first Cameron acquisitions in 1865 was *Whisper of the Muse,* one of Cameron's strongest early works which used Watts as a sitter. The Queen, however, appears not to have admired his work. In 1860, she went to visit the Great Hall at Lincoln's Inn, in London, which she had opened in 1845. In the hall, Watts had completed a monumental fresco entitled *Justice: A Hemicycle of Lawgivers* (1859). The Queen wrote: 'Afterwards we drove with Arthur to Lincoln's Inn to see the large Fresco by Mr Watts, which has been put up in the Hall. Were rather disappointed in it' (Journal, 25 February 1860).

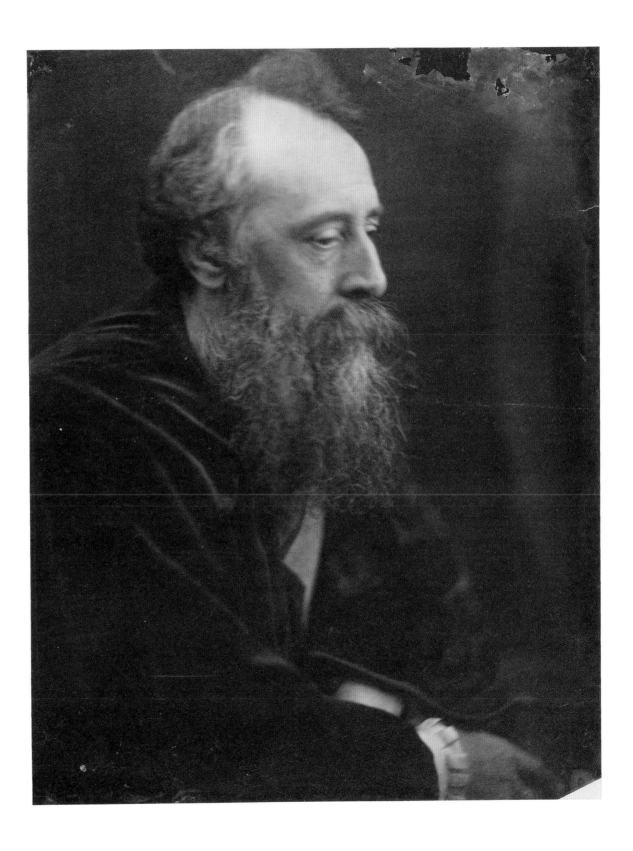

## 22

'Herbert Wilson', April 1868

Albumen print
31.3 x 25.6 cm
Signed and dated: *From life April 1868 Julia Margaret Cameron*
In an unknown hand: *12 / 6 son of Sir John Wilson*
With Colnaghi blindstamp
RCIN 2941862

Herbert Louther Wilson (1820–1905) was the son of Sir John Morillyon Wilson (1783–1868), who served with distinction in the Napoleonic War in Spain and in North America. Following in the footsteps of his father, Herbert joined the army in 1845 but sold his commission in 1854. He set himself up as a painter, concentrating primarily on society portraits. Wilson exhibited his work at the Royal Academy, the British Institute and the Grosvenor Gallery during the 1860s and 1870s.

He was a friend and follower of Richard Buckner, a painter whose work – primarily watercolours of Italian peasants and girls – was acquired by Queen Victoria and Prince Albert in the 1840s.

Two portraits by Cameron of Herbert Wilson were registered for copyright on 28 April 1868.

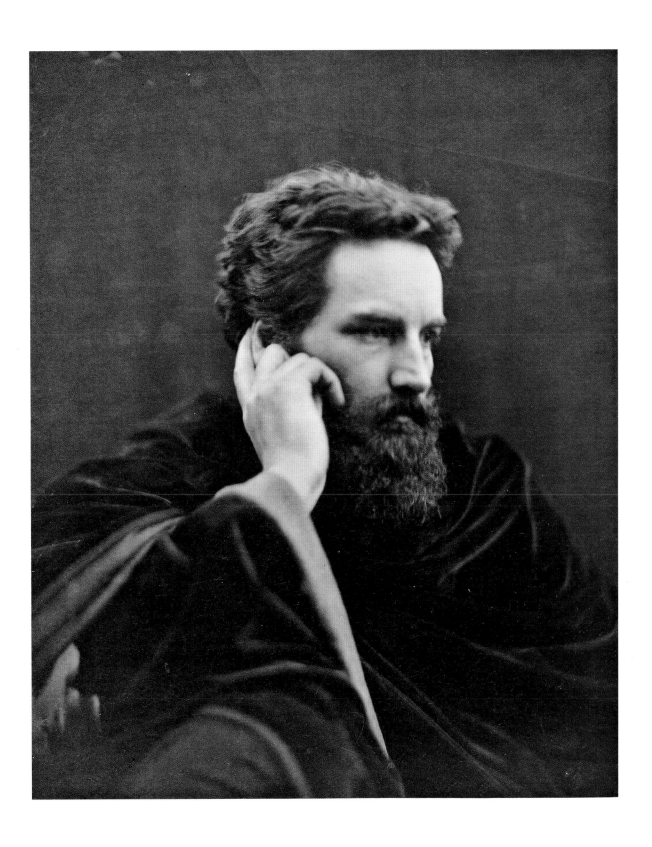

# THE WET COLLODION PROCESS

Details of this historic process have been included for their relevance to the text of this publication and should not be followed without professional advice or supervision.

## HOW TO PREPARE A GLASS PLATE NEGATIVE

1   Clean and polish the glass plate

2   Pour an even layer of collodion (a thick sticky flammable mixture made of gun cotton – nitrocellulose – dissolved in ether and alcohol) and potassium iodide onto the plate, covering it completely

3   Allow the collodion layer to set but not to dry

4   Sensitise the plate in a darkroom by immersing it in light-sensitive silver nitrate salts for 3–5 minutes

5   Place the wet negative in a plate holder and fix to the camera

6   Expose the negative for the desired length of time by removing the lens cap, usually between a couple of seconds and a couple of minutes

7   Replace the lens cap after exposure

8   Before the plate can dry, remove it from the holder and return to the darkroom

9   Pour developer (a solution of pyrogallic and acetic acids) evenly across the plate

10  When the image has developed sufficiently, halt the process with water

11  Immerse the plate in a bath of fixer (sodium thiosulphate or potassium cyanide) to remove the unexposed silver iodide

12  Wash the plate completely and leave to dry

13  Apply a coat of varnish to protect the negative

14  The negative is now ready to make prints from

This process was published by Frederick Scott Archer in 1851. It remained the most frequently used negative process until the early 1880s.

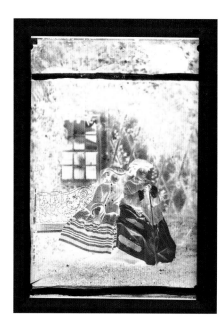

Roger Fenton, *The Princess Royal and Princess Alice, Balmoral, 1856*; wet collodion negative (RCIN 2079264) 45 x 37.5 cm

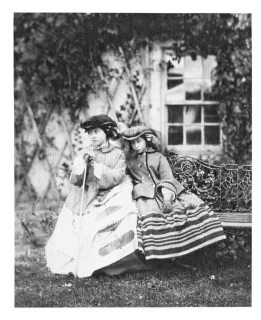

Roger Fenton, *The Princess Royal and Princess Alice, Balmoral, 1856*; albumen print (RCIN 2941851) 33.8 x 28.1 cm

## HOW TO MAKE AN ALBUMEN PRINT

1   Float a sheet of high quality writing paper on a solution of egg whites (albumen) and salt

2   When the paper has been coated, allow it to dry

3   In a darkroom, coat the paper with a silver nitrate solution to make it sensitive to light

4   Dry the paper

5   Put a negative and the paper together in a printing frame

6   Expose the frame to sunlight until the image develops; this can take from a few minutes to over an hour

7   Immerse the print in a bath of fixer to halt the process

8   Wash the print to remove unexposed silver salts

9   Tone the print, usually achieved through the addition of gold chloride

10  Dry the print

The albumen print was introduced in 1850 and was the most commonly used photographic printing process until the end of the nineteenth century.